The Philippines

ISLANDS OF ENCHANTMENT

Text by Alfred A. Yuson

Photographs by George Tapan

TUTTLE Publishing

Tokyo | Rutland, Vermont | Singapore

Published by Tuttle Publishing, an imprint of Periplus Editions (HK) Ltd.

www.tuttlepublishing.com

Text copyright © 2003 Periplus Editions (HK) Ltd
Photographs copyright © 2003 George Tapan
All rights reserved.

ISBN 978-0-8048-4372-0
LCC No. 2002107890
Printed in Malaysia

Previously publishing in 2010 as ISBN 978-0-7946-0632-9

Distributed by
North America, Latin America and Europe
Tuttle Publishing
364 Innovation Drive, North Clarendon, VT 05759-9436, USA
Tel: 1 (802) 773-8930, Fax: 1 (802) 773-6993
info@tuttlepublishing.com; www.tuttlepublishing.com

Asia Pacific
Berkeley Books Pte Ltd
61 Tai Seng Avenue #02-12, Singapore 534167
Tel: (65) 6280 1330, Fax: (65) 6280-6290
inquiries@periplus.com.sg; www.periplus.com.sg

Japan and Korea
Tuttle Publishing
Yaekari Building, 3F, 5-4-12 Osaki, Shinagawa-ku, Tokyo 141-0032
Tel: (81) 3 5437 6171, Fax: (81) 3 5437 0755
sales@tuttle.co.jp; www.tuttle.co.jp

19 18 17 16 15 7 6 5 4 3 2 1507TWP

TUTTLE PUBLISHING® is a registered trademark of Tuttle Publishing,
a division of Periplus Editions (HK) Ltd.

The Tuttle Story: "Books to Span the East and West"

Many people are surprised to learn that the world's leading publisher of books on Asia had humble beginnings in the tiny American state of Vermont. The company's founder, Charles E. Tuttle, belonged to a New England family steeped in publishing.

Immediately after WWII, Tuttle served in Tokyo under General Douglas MacArthur and was tasked with reviving the Japanese publishing industry. He later founded the Charles E. Tuttle Publishing Company, which thrives today as one of the world's leading independent publishers.

Though a westerner, Tuttle was hugely instrumental in bringing a knowledge of Japan and Asia to a world hungry for information about the East. By the time of his death in 1993, Tuttle had published over 6,000 books on Asian culture, history and art—a legacy honored by the Japanese emperor with the "Order of the Sacred Treasure," the highest tribute Japan can bestow upon a non-Japanese.

With a backlist of 1,500 titles, Tuttle Publishing is more active today than at any time in its past—still inspired by Charles Tuttle's core mission to publish fine books to span the East and West and provide a greater understanding of each.

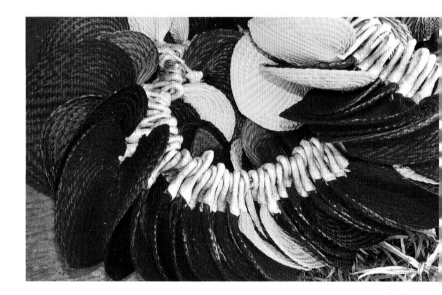

Below: Palmweave fans are dyed in various colors and strung up for sale at a town market in the Bicol peninsula.
Opposite: The face of the Filipina can be as haunting as the most memorable tropical design limned by nature's soft shadows.

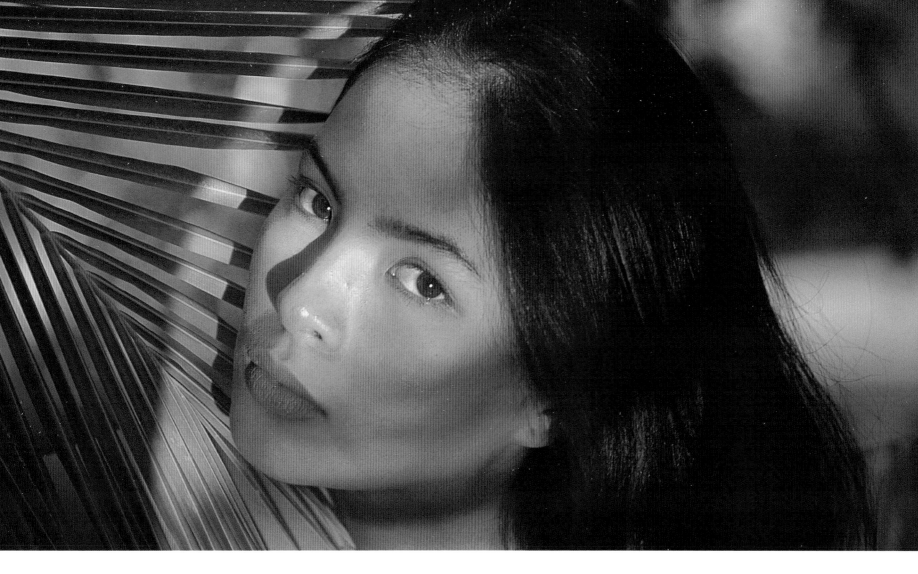

Contents

Islands of Promise, Islands of Hope

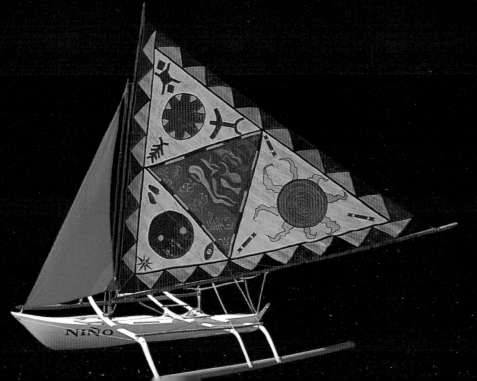

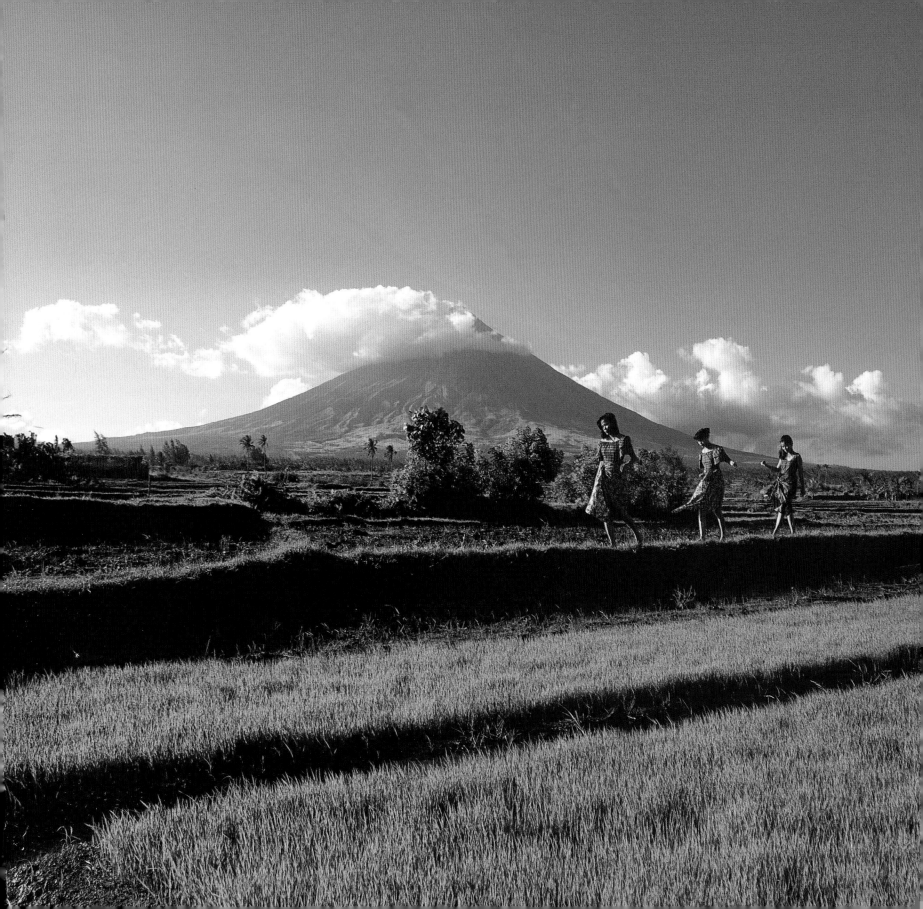

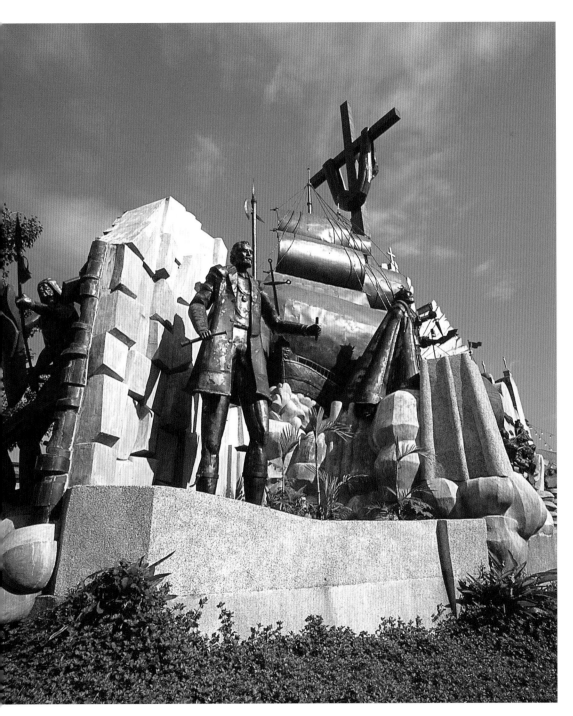

Amuch-quoted capsule history of the Philippines describes the country as having spent "three centuries in a convent and fifty years in Hollywood". This is not so much a putdown as a clever explanation of why the Philippines still struggles to find its bearings following three centuries of Spanish rule and half a century of American domination – not to mention several tumultuous decades of independence!

No ornate temple friezes proffer Asian motifs in the Philippines. In their place, the ubiquitous Catholic church stands as a reminder that the archipelago may well be oddly placed. Indeed, the Philippines – the plural country that needs an article to precede its collective identity – has gained the tag of being the odd-man-out in Southeast Asia. No spicy curry dishes, no indecipherable calligraphy, and no symbols of Asian inscrutability. But these islands lay claim to countless pockets of paradise – indeed for beach-lovers, some of the finest sand, surf and sun around.

Much as the Philippines may, from time to time, make the global headlines as a troubled arena – the scene of earthquakes, volcanic eruptions and armed rebellions or kidnappings that regularly make the front pages – a visit to the archipelago that serves as the Pacific gateway to Asia is rewarded with more

Previous page, left: A Boracay outrigger sports a painted sail.
Previous page, right: Cloud-capped Mayon Volcano looms in the far background as country lasses negotiate a rice paddy.
Left: Cebu City's Centennial Monument, the work of sculptor Eduardo Castrillo, depicts the historic confrontation between the natives and the Christianizing Spanish in 1521.
Right: A wading pool memorial of General Douglas MacArthur's return to Leyte in 1944 to liberate the islands from the Japanese.

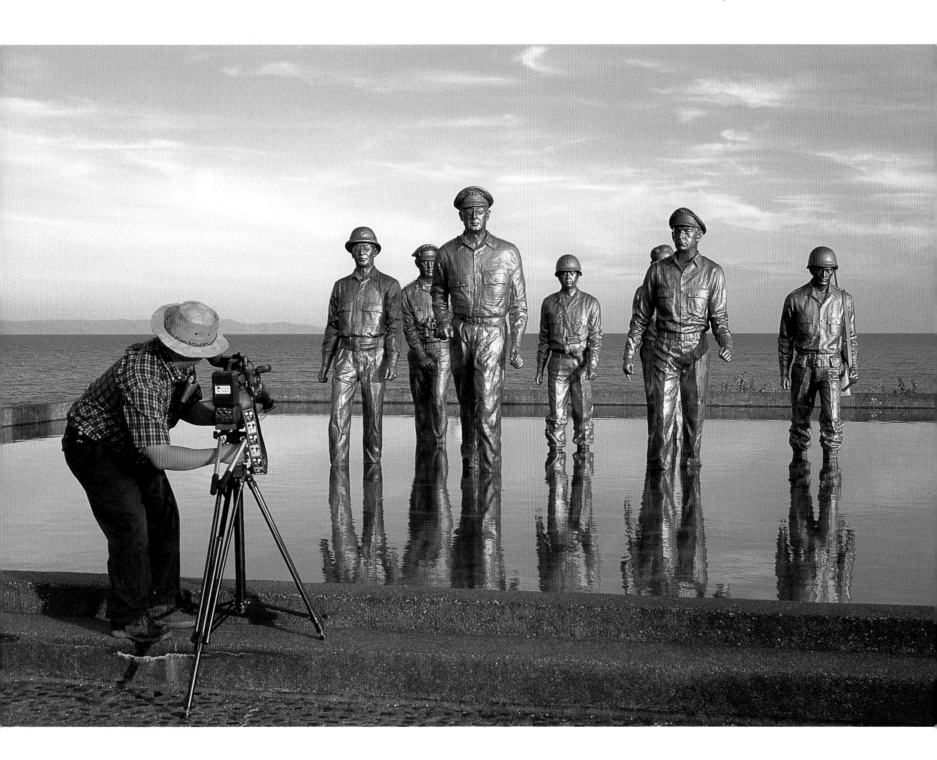

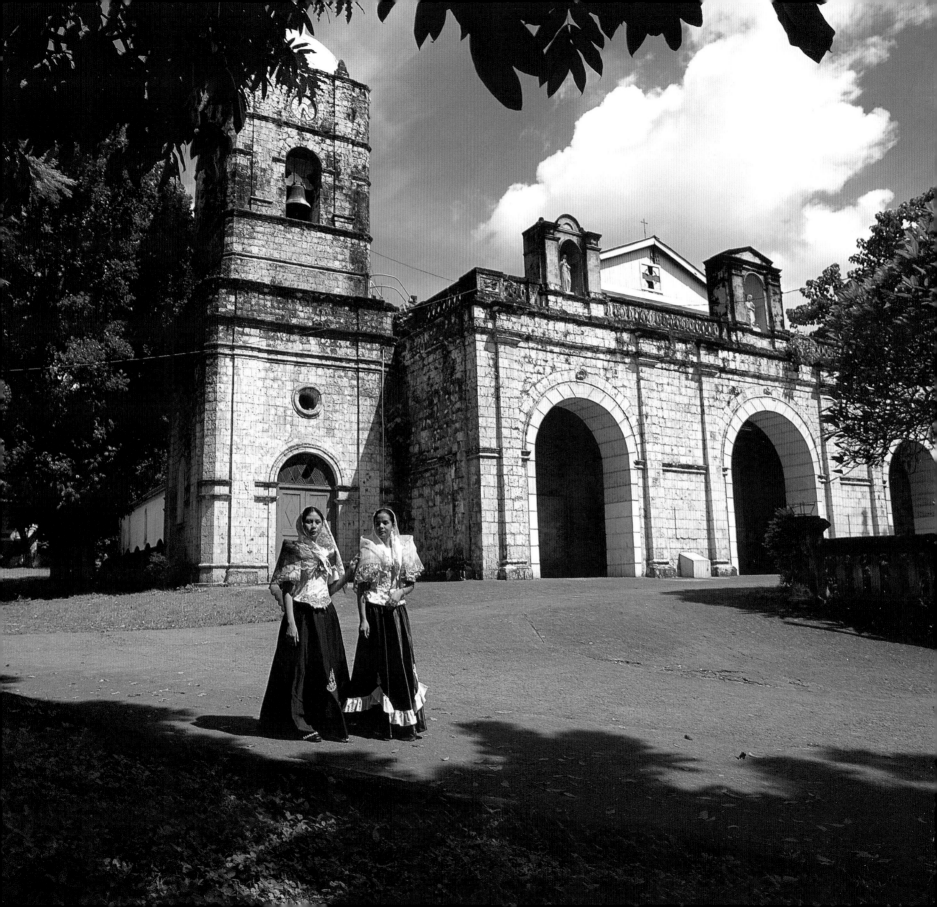

than a glimpse into an often befuddling, invariably fascinating culture, one full of joy, humor, courage and song in the face of all apparent adversity.

Alternately charmed and exasperated, the visitor comes away with the sense of having quickly bonded with, if not entirely understood, these people for whom grace under pressure and continual warm-heartedness amidst all kinds of chaos, are constant. It is here, after all, that People Power unseated macho presidents and installed women in their place. In these 7,000-plus islands, regional and tribal differences find common ground in the incomparable quality of hospitality.

Oh, don't mind those noisy urban demonstrators burning effigies and waving placards of ridicule and hate. When they take a break, they'd just as soon escort any foreigner for a snack, or ask him to sing along with them over beers in a videoke bar.

On one end of this perplexing psychological spectrum you may witness mass hysteria occasioned by nattily-dressed evangelists or shamans, or the cities' feisty tri-media, and on another the blasé reaction to a tabloid headline screaming "Woman gives birth to fish!"

These are people who, when they're island-bound, can't do without myths, fables and legends but when trapped in the cities become so concerned with arriving at a collective identity that they hastily conclude there may be none, at least as of the hour.

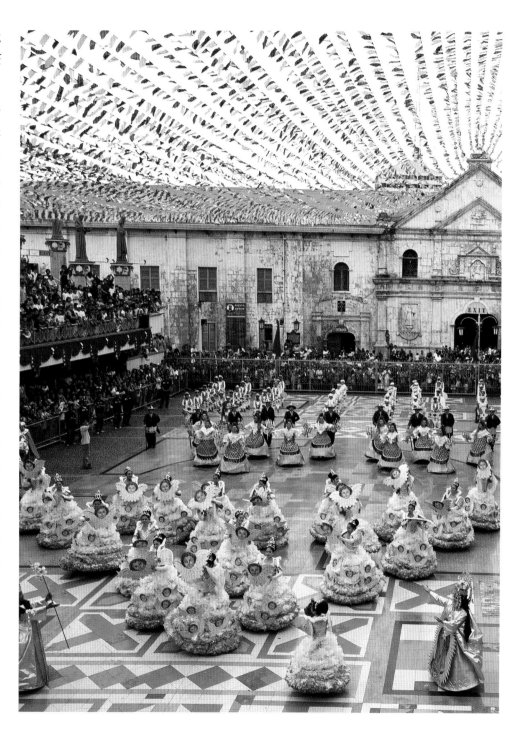

Left: At the courtyard of Pilar Church near Ozamis City in northern Mindanao, ladies in their finery hark back to a distant Castilian past.
Right: Fabulously dressed participants at Cebu City's Sinulog Festival.

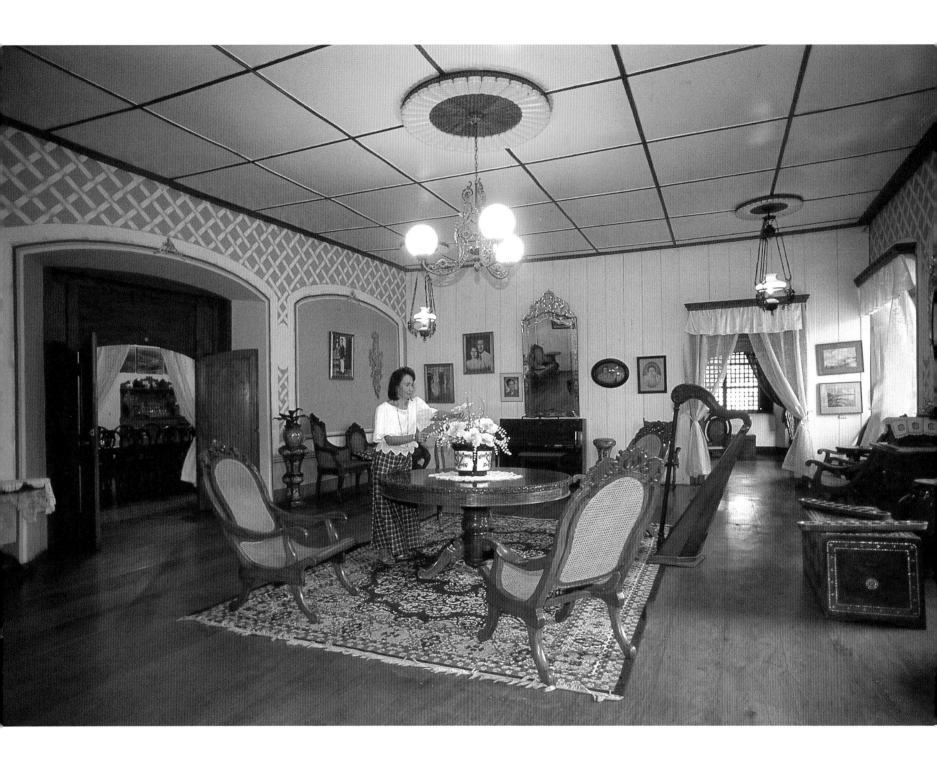

The Philippines is a toddler of a nation, given to much gnashing of teeth and thumping of chest. But the natives laugh at themselves so easily that every crisis or tragedy spawns a fresh round of jokes that are then "texted" from one cellphone to another, down to the remotest barrio.

The rewards are just as profligate and indiscriminate. One becomes intimate with the high incidence of feminine pulchritude. One hears often of well-placed *padrinos* in high places because of family connections. The Roman Catholic Church meddles with the official population control program while the birth rate remains the highest in Asia. But in the face of this cultural schizophrenia is that disarming smile that bespeaks warmth, faith, and a confidence in an environment where one can thrive in the comfort of the best massage under a swaying palm.

Baguio City, the capital of Mountain Province, is the nation's "Summer Capital". From March to May, its population quadruples as lowlanders flock to the highland resort city established in the early 1900s by the Americans who wanted a respite from the lowland heat.

Lying to the south is the coastal province of Pangasinan where a steady stream of foreigners seek out the world-famed psychic healers who are reputed to be able to perform bloodless surgery with their hands and who, to this day, command a cult following.

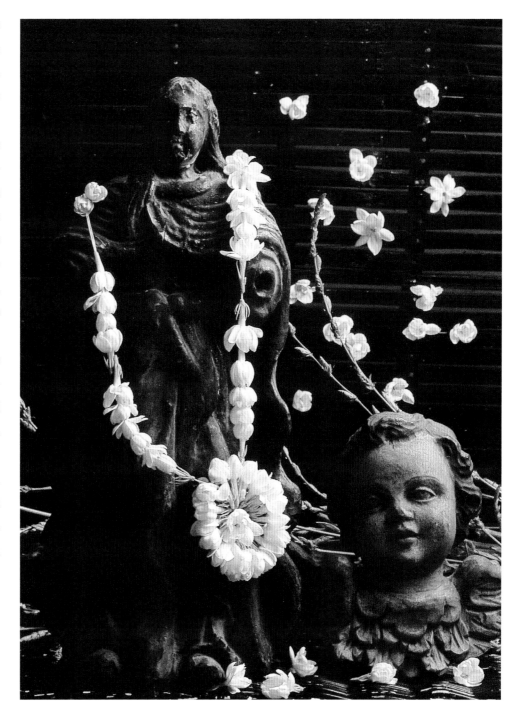

Left: An ancestral house remains a repository for family treasures and heirlooms. Colonial-era furniture includes hand-carved armchairs with woven rattan strips for cool comfort.
Right: The delicately fragrant *sampaguita*, a jasmine variant, is the national flower. Its buds are usually strung up as a garland. Here it pays homage to a wooden saint and a cherubim.

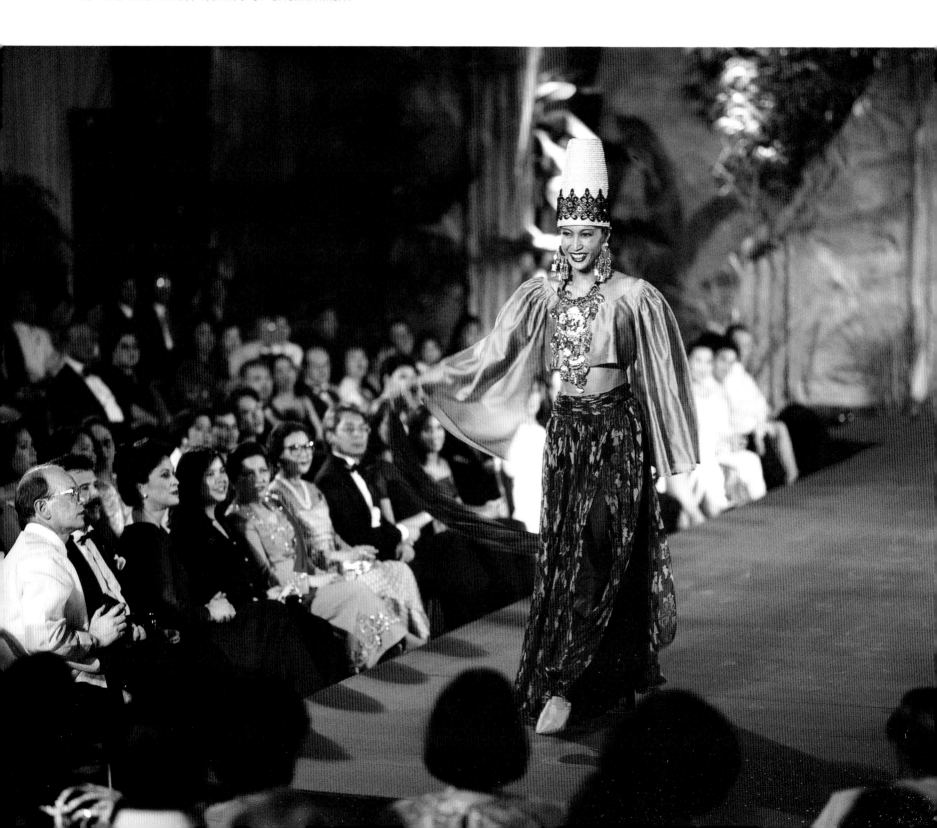

Farther south still is the dense spread of Metro Manila, made up of several contiguous cities and municipalities. Its feverish daily activity centers on the financial districts, glitzy shopping malls, privately guarded villages, administrative and educational institutions as much as on the other extreme: those congested shanties of the so-called "informal dwellers" (read "squatters").

Southern Luzon spells beaches for good diving, and continues all the way southeast to the Bicol Peninsula where the prime attraction is Mayon Volcano, said to be the world's most perfect cone. It puts on a show every decade or so.

The Visayan Islands are arguably the best come-on for sun and surf aficionados, with Boracay Island regularly rated by a British travel magazine as "the best beach in the world." Then there is Mindanao, still an intriguing large island of contrasts and strife. A traveler may enjoy city comforts with the freshest, most affordable steaks of tuna and black marlin, marvel at orchids, durian and mangosteen in Davao, surf on world-class waves in pristine Surigao, or face another kind of hazard deeper south where renegade bands still spit in the eye of authorities.

It is the archipelago's diversity which is the seed for its unique culture. Consequently the islands continue to beckon with romance, enchantment and splendiferous promise.

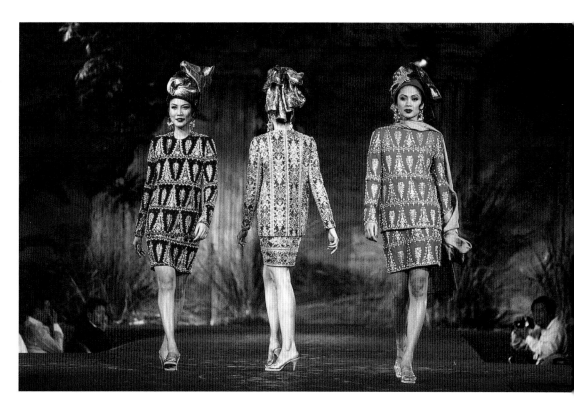

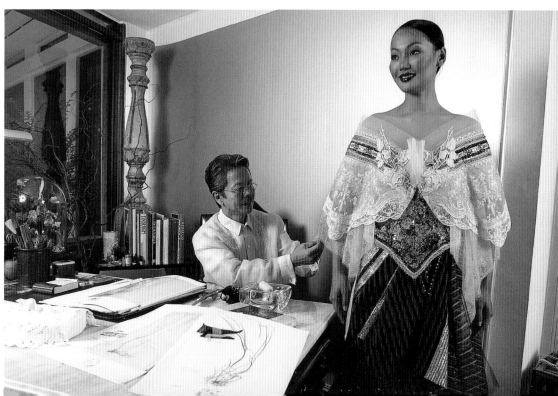

Left: Manila fashion shows are a staple of the culture and entertainment scene, where top-class designers compete in creating a unique form of Filipino fusion design by incorporating indigenous fabrics, motifs and embellishments.

Right, top: Filipina models often grace the Asian and global catwalk. A good number count among the highly-paid international models based in Europe and New York.

Right, bottom: Prominent Filipino haute-couture designer, Joe Salazar, does a last-minute backstage check before a fashion show.

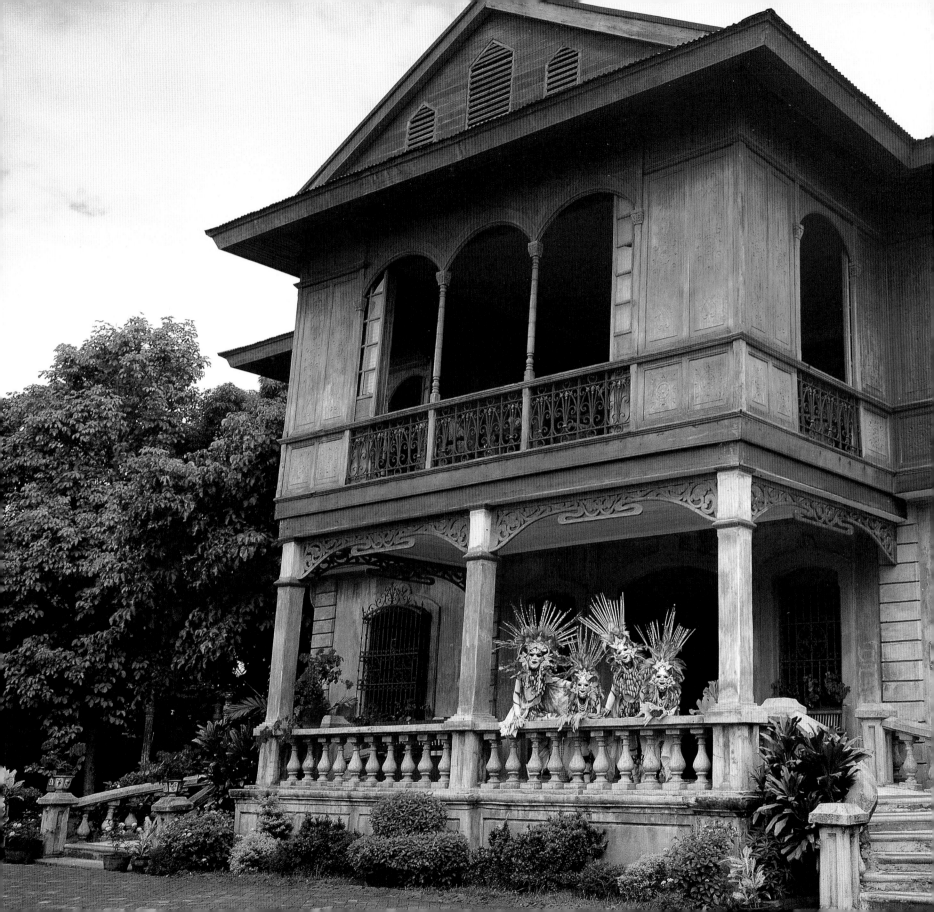

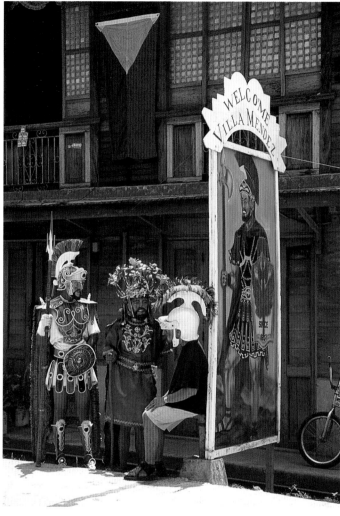

Left: An ancestral house in Silay, close to Bacolod City, has been converted into a museum called Balay Negrense, showcasing the Negros Occidental lifestyle. Here it offers some respite for *Masskara* revelers.

Above: A trio of costumed participants in the *Moriones* festival in Boac, Marinduque, find time for a break from the hectic activities on Good Friday. As Roman centurions, they will enact the chase of the "good thief" Barabbas, until it ends in a mock beheading.

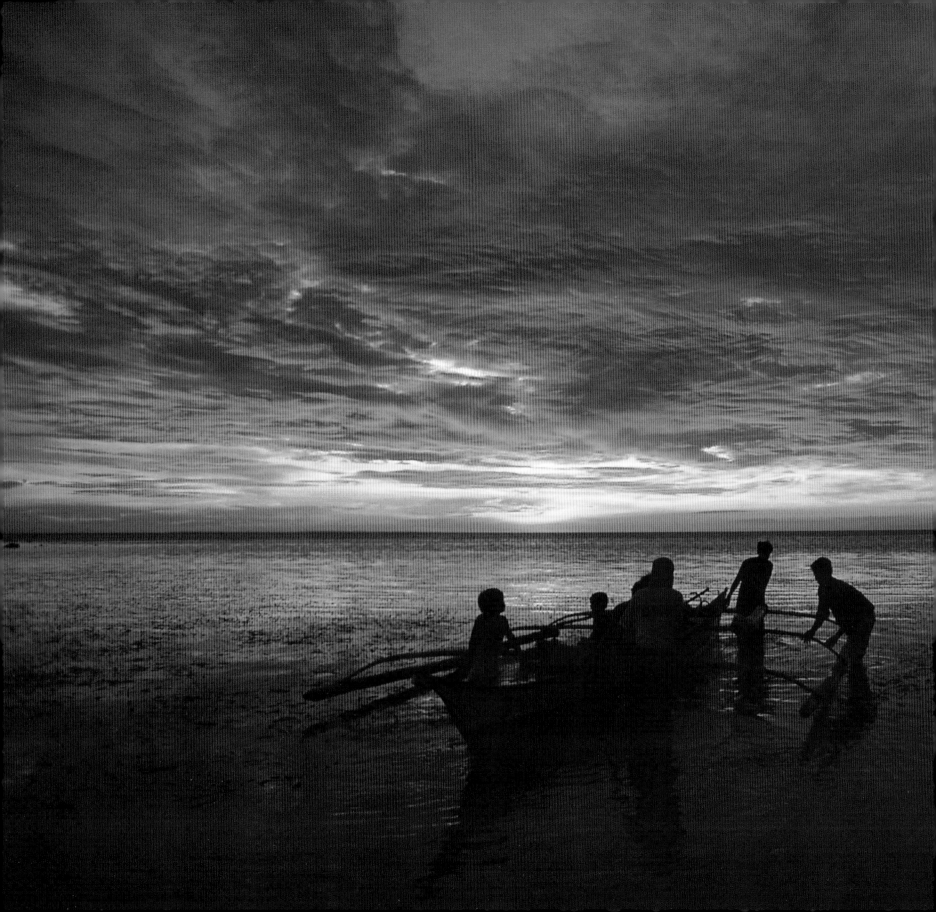

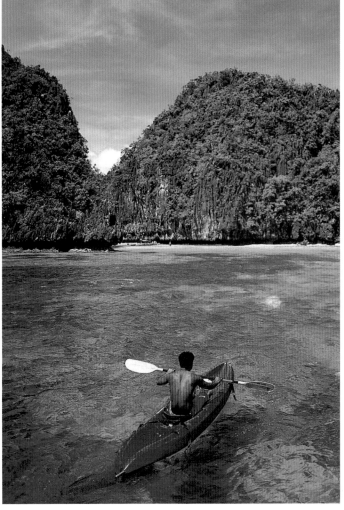

Left: Fishermen of Malapascua Island, north of Cebu, push off toward a typically splendid sunset with their double bamboo outrigger.
Above: A modern kayak serves as the best conveyance for island- and lagoon-hopping at the fabled El Nido resort in northern Palawan. Here sheer limestone cliffs rise above white-sand beaches and crystal-clear waters.
Overleaf: Dubbed "the world's most perfect cone", Mayon Volcano in Albay province erupts almost every decade, providing a fascinating if fearsome spectacle.

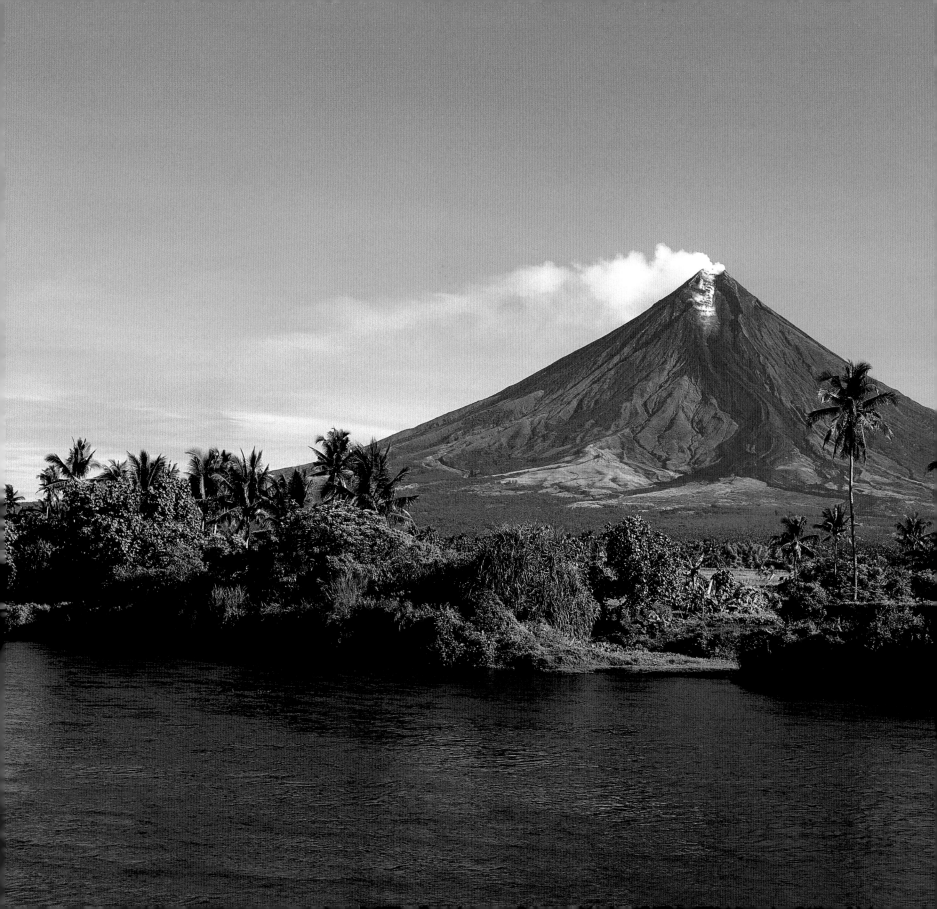

"Filipinos feel the need to be with other people and can tolerate crowding, among family members or among friends, because this creates a sense of intimacy. Wanting nonetheless to protect their own space and respect that of others, Filipinos take an indirect route: words are carefully chosen, even when expressing strong feelings, so as not to hurt other people."

— Fernando Nakpil Zialcita, *Filipino Style*

A People with a Passion for Living

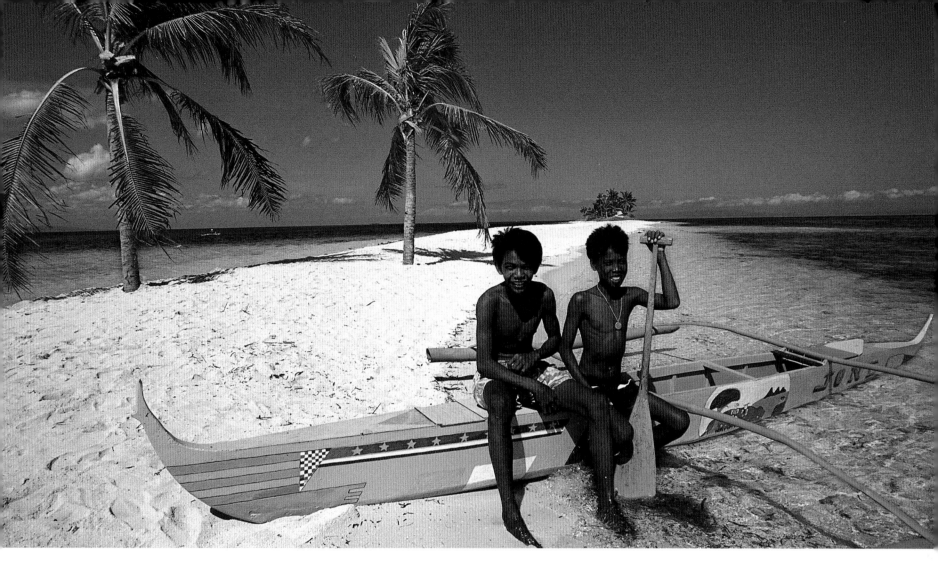

There are, it is said, two kinds of Filipinos. The foreigner might first come into contact with one kind, and be totally unaware of the existence of the other. There is the educated upper class, and then there are the overwhelming number of socially, politically and economically marginalized indigenes, islanders upland dwellers and urban settlers. The latter are called the *masa* or the masses, always a force to reckon with for the democratic vote, but whose numbers have weighed down every government with conundrums ranging from resettlement to livelihood provision.

Fingers point to the primary problem of population control that, due to the strong influence of the Catholic Church, is nearly an untouchable issue. As a result, the Philippines retains the dubious distinction of having the highest population growth rate in Asia, and one of the highest in the world.

In the past three or four decades, Filipinos have also been known to engage in a diaspora of epic proportions. While the country has an estimated 80 million residents, expatriate Filipinos number well over seven million, with countless more yearning to try

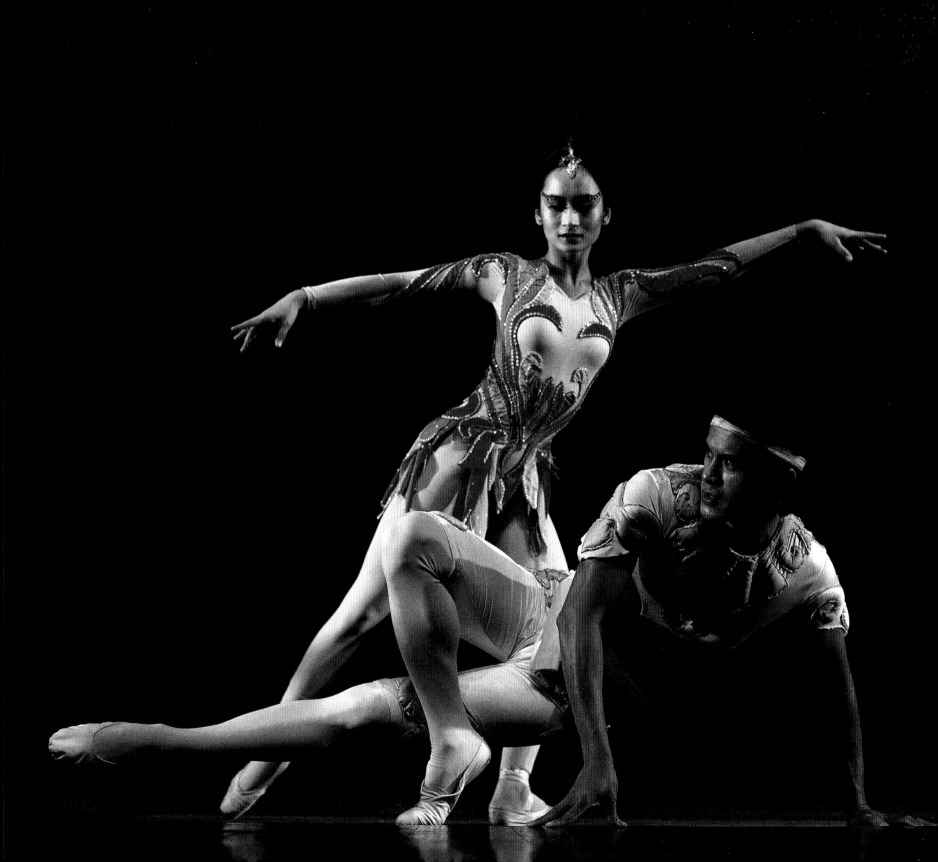

their luck overseas. While half the number of overseas Filipinos have found greener pastures as professionals in "Mother America," others are found all over the world – nurses and engineers in the Middle East, domestics in Europe and Asia, nightclub entertainers in Japan, IT experts and corporate executives in Indonesia or Malaysia, teachers and health workers in Africa, and members of musical bands throughout Asia.

Then there are the Filipino seamen, who comprise the highest number of any nationality found in ships all over the world. A point of national pride, as well as a typical joke, is that any mishap in any part of the world is likely to find a Filipino in the roster of victims.

The phenomenon of the overseas Filipino worker (OFW) makes a significant contribution to the national economy, such that the OFWs are hailed officially as "national heroes". A token few are awarded prizes amid media glare when the deluge of *balikbayans* or returnees clogs up Manila's international airport before Christmas.

It is an intriguing set of layers of social, cultural and regional divide that comes to play when Filipinos encounter one another, whether at home or abroad. One's accent usually betrays regional origins and economic status. Fluent use of English marks the economic or academic elite; even one's use of the Filipino language will unmask the city-come-lately or professional parvenu. Over 80 regional languages and tribal dialects are still spoken throughout the islands.

The most popular Filipino may well be Manny Pacquiao who became the first boxer in history to hold world titles in seven different weight divisions. His humble origins stand him

in particularly good stead with the adoring masses. Then there is Efren "Bata" Reyes, also known as "The Magician," whose No. 1 world ranking as a professional billiards player has spawned numerous pool halls – from air-conditioned parlors to al fresco settings – in every Philippine city. Eugene Torre, the first Asian chess grandmaster, is still revered, and international bowling champion Rafael "Paeng" Nepomuceno is still another legend.

In sports, as in political or social administration, Filipinos like to deride their penchant for exhibiting "crab mentality". The joke is that Filipino crabs can be placed in a pail without a lid, and not one will escape as the others will pull any pretender down in no time. Filipinos abroad are also well aware of this

Previous page, left: Spartan Tausog wear from Mindanao.
Previous page, right: Young fishermen savor the breeze on a tiny isle between Cebu and Bohol.
Opposite: Lisa Macuja and Eddie Elejar are prime exponents of modern ballet, performances of which are staged at the Cultural Center of the Philippines.
Below: Lea Salonga has gone on to greater success after being discovered by London's West End for *Miss Saigon*.

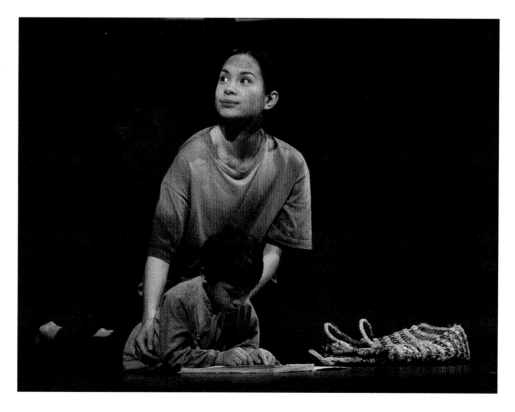

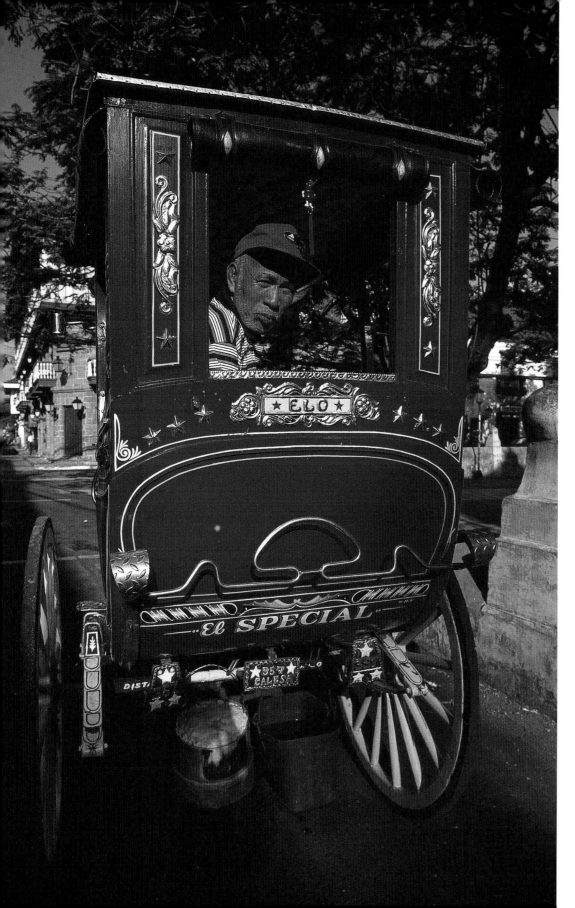

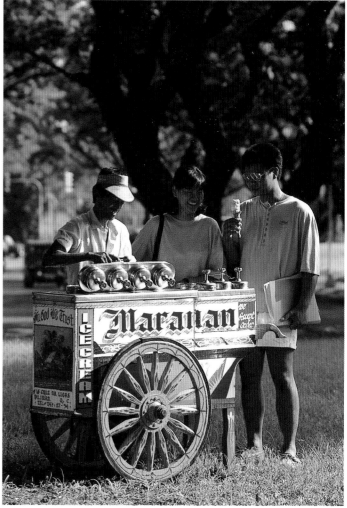

Left: A *cochero* or horse-rig driver peers out of his *calesa* — a transport relic from the Spanish past.

Above: The "dirty ice cream" cart, as it is fondly called, is wheeled around city parks and plazas by tireless vendors.

Opposite: The young Filipina in sheer, embroidered finery is as enticing as the tropical islands can get.

syndrome, yet exhibit the same traits nonetheless. Someone who fails to get elected to lead a group immediately forms another. This leads to the absurdity of having two or more clubs representing Filipinos in a small town in the United States, usually ranged against one another as regional groupings that have been carried over across the Pacific.

For a picture of the Filipino as individual achiever, however, none is framed and gilded with more distinction than that of the 19th-century Renaissance man, hero and martyr, Dr. Jose P. Rizal. Scholar, physician, poet, writer, scientist, polyglot, traveler and political reformer, Rizal crammed into his 35 years all the possible exploits of the mind and heart that were achievable during his time. His two novels, written in Spanish, were banned in the Philippines for their satirical take on the friars and other authorities. On the eve of his execution, he penned a long poem entitled "My Last Farewell" which he concealed in a brass lamp that was given to a sister. The poem, in its original Spanish and translated into English, is featured in a stone marker behind the landmark Rizal Monument located in Rizal Park, facing Manila Bay. Standing close to where he was shot in 1896, the monument marks Ground Zero in the reckoning of land distance from Manila to any point in the Philippines. Flanked by honor guards round the clock, it is also where heads of state must pay homage when they visit.

Fantasists put forth a scenario whereby the elite of the millions-strong, expatriated Filipino work force – those who have shown in the world arena that they can manage, as well as be effectively managed – may someday decide to form an army of saviors to take over the oft-plagued country of birth.

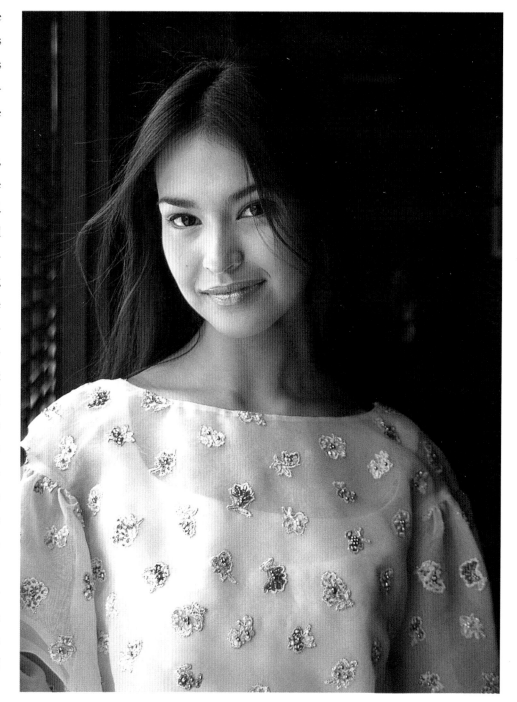

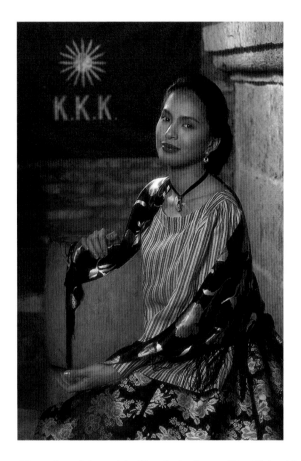 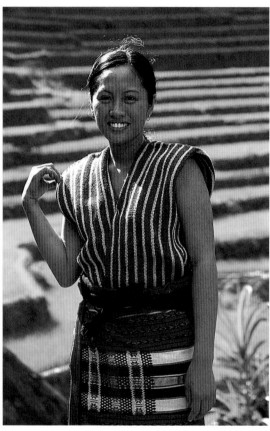 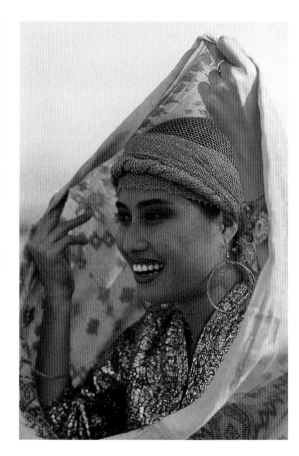

Above, from left to right: The alluring faces of the Filipina. Movie and stage actress Chin-Chin Gutierrez is clad in vintage finery in homage to the last years of the 1900s, as indicated by the revolutionary flag in the background. Dressed traditionally and standing before rice terraces, this young girl comes from the Cordillera highlands of Luzon. A Mindanaoan lady sports an intricate headdress as part of an elegant Muslim garb.

Every Filipino knows what the major problems are and how they can be solved – minimize corruption, revitalize education, strengthen law and order, achieve unity, peace, and economic stability. But it will take a great achiever to even initiate the long process. Perhaps the lead can come from enlightened Filipinos themselves who will say enough is enough, and band together again in another, final manifestation of People Power to throw the old unworkable system out. This would include political patronage that remains a throwback to the *padrino* system of spoils and landowner privilege that was a dubious legacy of Spanish colonization. It may even require reducing the influence of the Roman Catholic Church.

But who best to accomplish such reforms than the Filipino who has faced challenges abroad and proven himself rulebound yet efficient? He may be a *mestizo* – of Malay stock but with Spanish or Chinese blood – or someone of a darker brown who came from the boondocks but succeeded in making a name for himself overseas. She could be the Filipina novelist who has penned a bestseller in the United States, a finance expert on Wall Street, or a United Nations manager who distinguished herself in Geneva. This Filipino, male or female, may be all of these, and more: the neurosurgeons in the Big Apple and

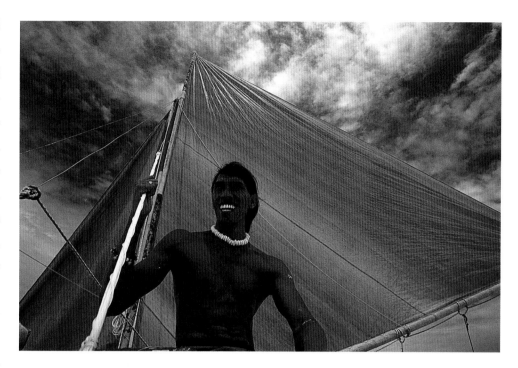

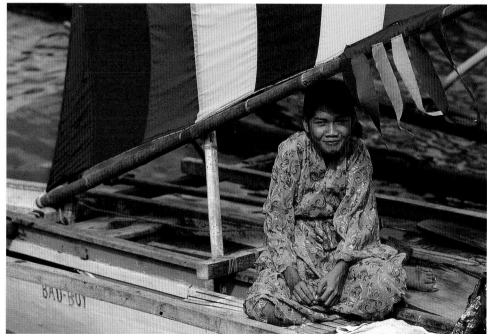

Right, top: A necklace of puka shells gathered from his habitat's white-sand beaches is the only concession to adornment for this native of Boracay island off Panay in the western Visayan Islands. He steers the *paraw* or dugout boat with a pastel-colored sail. A *paraw* regatta conducted in summer off Boracay has produced artistically painted sails in a breezy toast to Mondrianesque geometry.
Right, bottom: Off Zamboanga in southern Mindanao, the typical dugout with bamboo outriggers, called the *vinta*, is traditionally equipped with brightly colored sails.

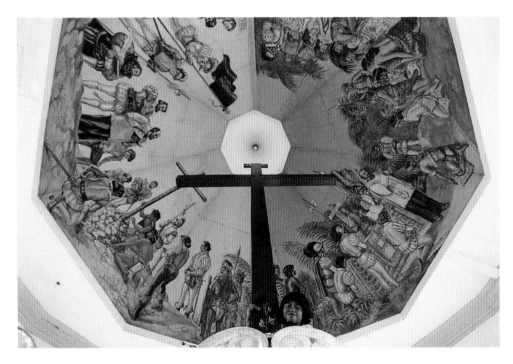

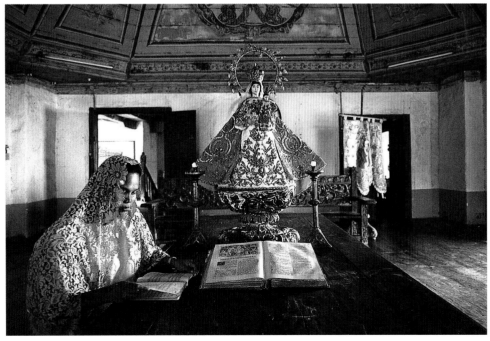

the Windy City, the construction magnates who have built good roads and elegant palaces in Egypt and Brunei, the editorial cartoonist or graphic designer in Singapore, or the young Filipino-Americans who joined the career boom in cybernetics and who now rule the roost in Silicon Valley.

This army of expatriates (always according to the fantasy) may well decide that the currency, the equivalent of billions of pesos, which they remit annually to the homeland could be better managed to run a country properly. They will come home and take over, so that the Philippines will not just be known anymore as an exporter of seamen, domestics and international beauty competitors.

Oh, the curious, Americanized nicknames that Pinoys (as Filipinos like to call themselves) have adopted – "Bongbong", "Dong", "Ging-ging", "Apples", "Marivic", "Pete" (instead of Pedro), "Girlie", or the very popular "Boy" – may stay. And the solemn rituals, merry festivals, odd superstitions, social rites of baptism, weddings, birthdays and other anniversaries can remain untouched, powerful as these are in providing a unifying bond of custom and ceremony.

But this time the strong ties of kinship will spell more than just the clannishness attributed to the typical syndrome of the

Left, top: On the domed ceiling of a small kiosk housing Magellan's Cross in Cebu City, a mural depicts the arrival of the Spanish conquistadors and subsequent evangelization. The wooden cross is a replica, but is supposed to contain part of the original cross left behind in 1521.
Left, bottom: Religious icons in rich vestments and ecclesiastical volumes are among the attractions in Boljoon Church in Cebu.
Right: Weddings are a daily feature at San Agustin Church in Intramuros, Manila, one of the most magnificent and best-preserved examples of colonial architecture.

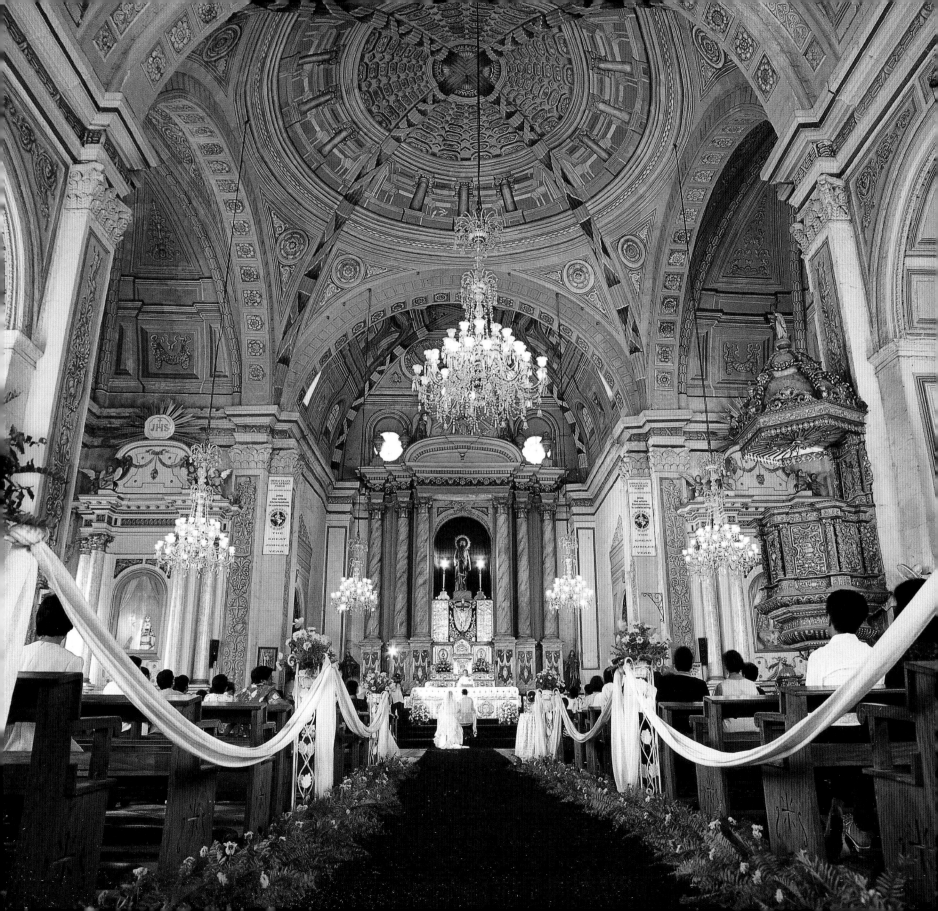

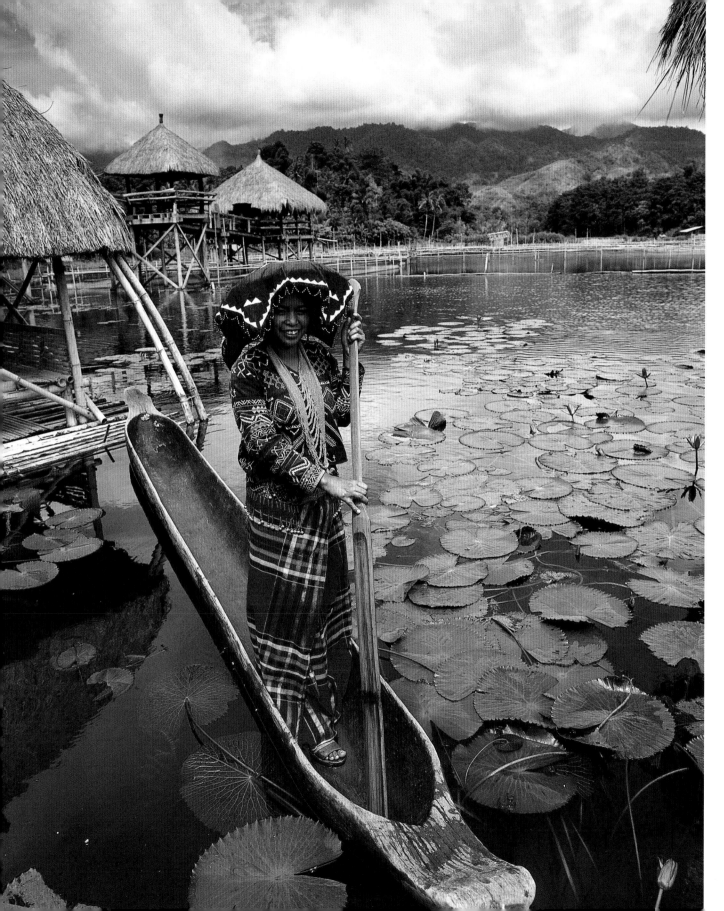

Left: A T'boli tribeswoman steers her dugout canoe through lotus pads in scenic Lake Sebu in the highlands of Cotabato in Mindanao. Her finery is typical of daily wear, as the gracious T'boli are known for their elegant ways despite a simple lifestyle. One hears a T'boli maiden approaching by the tinkling of little brass bells adorning her belt, bracelets and anklets.

Opposite, top: Some of the younger folk among the cultural communities in Mindanao have embraced Christianity. Note the crucifix worn by this otherwise traditionally garbed lass.

Opposite, bottom: A farmer negotiates his way atop volcanic rocks strewn over the Albay landscape — grim reminders of the occasional fury of Mayon Volcano.

extended family. They will serve as the bedrock upon which an invigorated, better-led, better-managed and more competitive Philippines will draw from to be able to emerge from Third World status.

This fantasy may never happen.

Filipinos may slog along and continue to teach foreigners (as maids do their wards in the Middle East) the curious value of worship, while handling the rosary or an image of the Blessed Virgin Mother. The rich matrons may continue to conduct pilgrimages to the shrines of the faith, from Jerusalem to Naju in South Korea, and Lourdes to Medjugorje in Croatia. When they come home, they will make a beeline to the latest mall, and give meaning anew to the word "Imeldific" as modifier for the proclivity to indulge in shopping sprees and ostentatious display.

The Filipino politician may continue to dispense largesse and expect himself to be re-elected, since he refuses to relocate shanty dwellers even if their jerry-built homes stand at great risk on densely crowded riverbanks. And the ethical achiever may simply go against the odds and continue to abide by his devotion to family, and preservation of the family name.

In the farmlands, the Filipino may continue to guide his carabao, his beast of burden, in plowing the fields in hopes of a storm-safe harvest. While the nomads, including aborigines, may move from mountain to mountain, leaving burnt patches of forest in their wake as they employ the age-old practice of swidden subsistence. And the Muslim Filipinos in southern Mindanao may continue to be divided between those who seek education and peace with the predominant Christians, and those who can only sleep well with a gun.

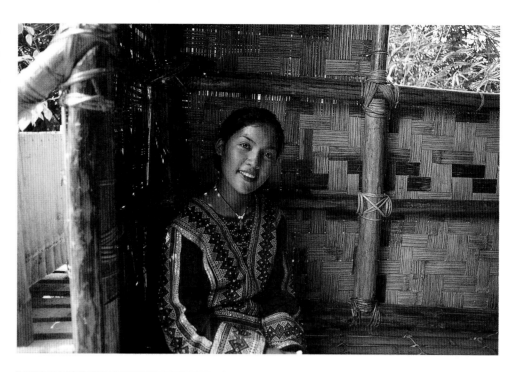

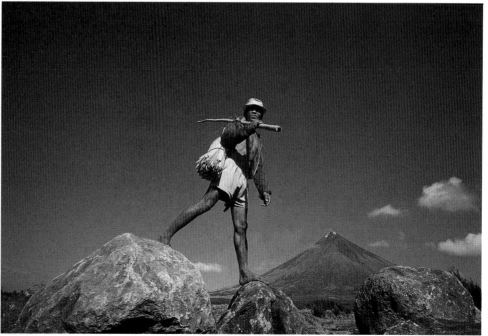

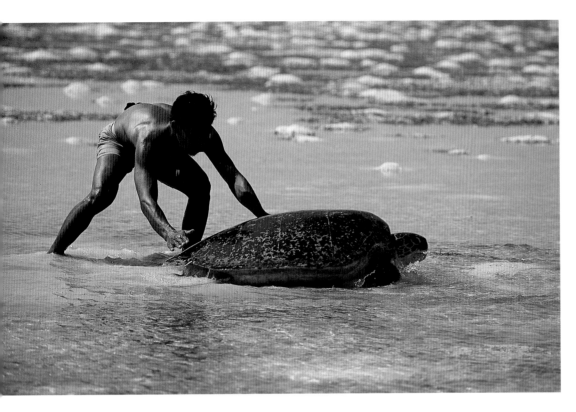

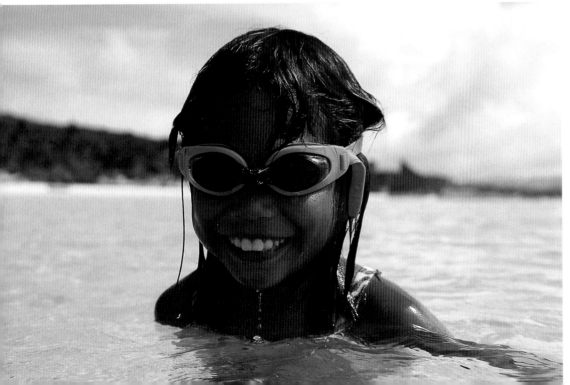

Throughout the archipelago, the fishermen may go out in their small *bancas* on moonless nights, and return at daybreak to lament the unfair competition from politico-backed companies that engage in illegal trawling.

Elsewhere on the beach, however, there may be some young city dwellers out on a weekend to enjoy a dive and a bonfire party. In the plush resorts, spas and masseuses give comfort to domestic and foreign tourists – a moment of pampering for the well-heeled.

In Manila and the other big cities, the malls are full of shoppers, cinema-goers and aficionados of those videogame arcades. The restaurants and nightclubs are alive and brimming with good cheer, self-deprecating jokes, laughter and song, and the communal embrace of family or camaraderie. And in every town during summer, colorful buntings adorn the streets that await the procession of saints' images and lovely maidens in ornate gowns.

The visitor can only be beguiled by such magic of tropical realism. And despite the much-publicized adversity, nowhere in Asia is the smile of welcome as inviting and authentically heartfelt as that of the Filipino's.

Left, top: A marine conservationist gently aids a green sea turtle in the Tubbataha Reefs in the Sulu Sea. The reefs are a protected environment, and have been declared a world conservation site by UNESCO.
Left, bottom: In southern Mindanao, the Badjao sea gypsy children learn to swim and dive before they can walk. They are then taught to comb the seabed for pearls and other underwater bounty.
Right: A Tausog boy studies turtle hatchlings making their way to sea on Balabac Island off the southernmost tip of Palawan, a boat-ride away from neighboring Malaysia.

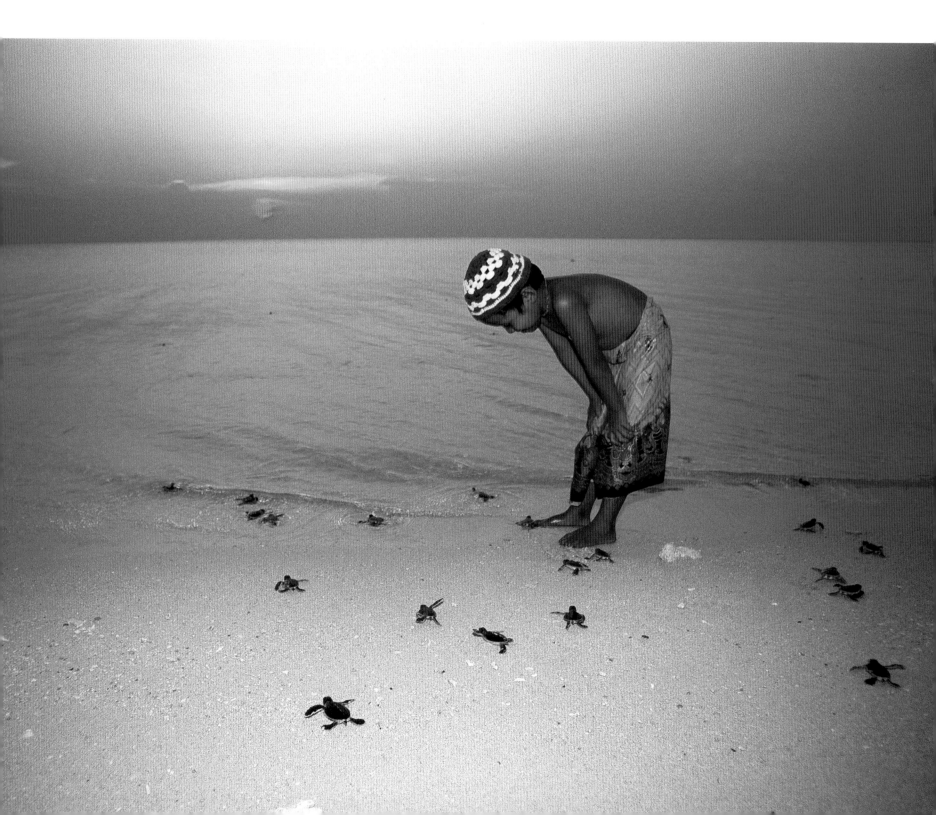

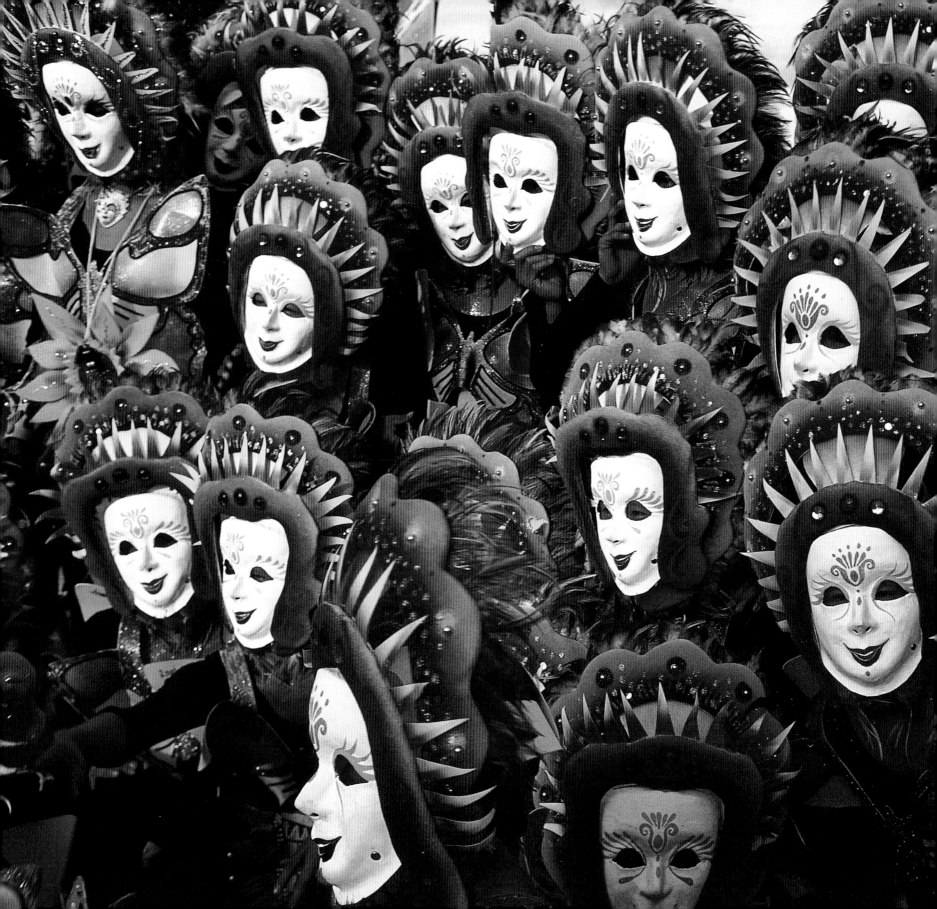

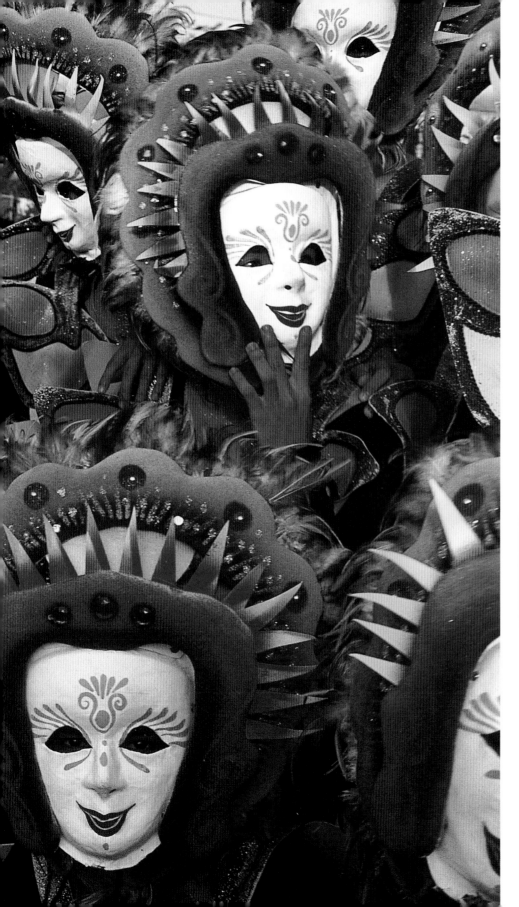

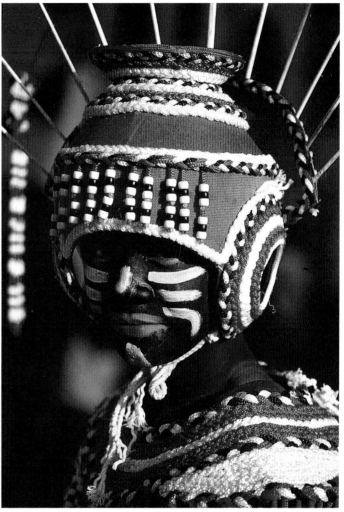

Left: The *Masskara* festival in Bacolod City features resplendent costumes replete with masks. Well-organized revelers dance through the streets to the beat of drums. At the end of the day, the best disciplined, most artistically garbed and creative performing group receives hefty prizes.
Above: A participant in the three-day *Ati-Atihan* festival held in Kalibo, Aklan province sports an intricately designed headdress and cape.

"Beside a spacious beach of fine and delicate sand and at the foot of a mountain greener than a leaf, I planted my humble hut beneath a pleasant orchard, seeking in the still serenity of the woods repose to my intellect and silence to my grief."

— Excerpt from a poem by Jose Rizal, *Mi Retiro (My Retreat)*, written in Spanish between 1894 and 1896

THE ARCHIPELAGO OF A THOUSAND SURPRISES

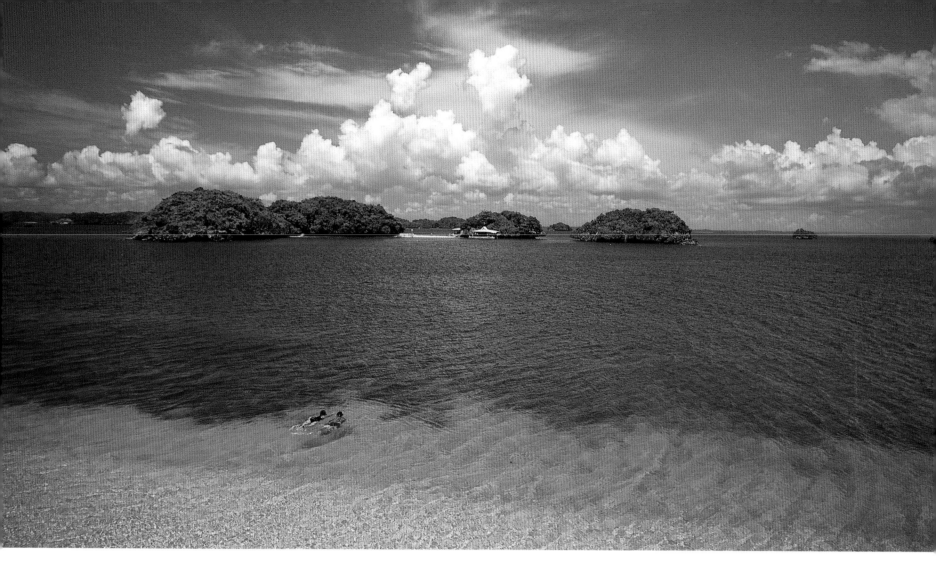

The northernmost islands of the Philippines, collectively known as the Batanes, lie closer to Taiwan than to the country's administrative center of Manila. Throughout the monsoon season, typhoons from the Pacific batter the rugged Batanes. It is a region where quaint stone houses, windswept moors, rocky coves and picturesque glades bring to mind a wild Irish landscape rather than a Southeast Asian outpost.

Here the telephone has only recently been established. There is still no television, but a few enterprising families bring in videotapes of local and foreign movies for paid public viewing. A plane lands daily in the capital town, Basco, but visitors can only be sure of a return flight during the dry summer months (January to May), before rains and storms spawned in the Pacific wreak havoc on schedules.

The tourism industry in the Batanes remains modest, but visitors who manage the trip vouch for the rewards of a salubrious climate, photogenic delights, and a warm reception among the modest lodges that have only recently been opened. And they come

away with a treasured memory of an island from another time where, on cobble-stoned streets, school children greet new faces in respectful English, where rock fortresses atop distant grassy hills are an archaeological marvel, and where no one has landed in jail for decades (and not just because there isn't one).

The Batanes Islands are not a fair representation of the Philippines. They suggest, rather, the serendipitous presence of unusual destinations and serve to emphasize the surprising range of geographical diversity within this tropical country.

Contemporary research has uncovered modest Chinese accounts that referred to the island of Ma'i in the South China Sea. This island would later become known as Luzon, the largest in the archipelago and arguably its geographical epicenter.

In northern Luzon's Cordillera range, the high altitude offers travelers with time to spare fine pine stands, oak forests and cooler weather as a complement to its indigenous montagne culture. Here the major attraction is the magnificent rice terraces – dramatic stairways to the skies carved out of steep mountainsides 2,000 years ago. The Banawe rice terraces – arguably the grandest of the lot – have been declared a UNESCO World Heritage Site. Lording it over valleys and gorges, the rice paddies

Previous page, left: Delicately sweet *lanzones* fruit are borne by a young maiden of Laguna province.
Previous page, right: The islets off Coron Island in northern Palawan are a delightful haven for snorkelers and divers.
Left: A crater lake has formed atop Mt. Pinatubo, the active volcano in western Luzon that wrought havoc in 1992. Helicopter tours can be arranged for a bird's-eye view of the crater, or one may sign up with local travel agencies for a guided trek up the forbidding terrain.
Right: The rice terraces in the northern Luzon highlands, which were called the "Gran Cordillera" by the Spanish, were carved out of steep mountainsides all of 2,000 years ago.

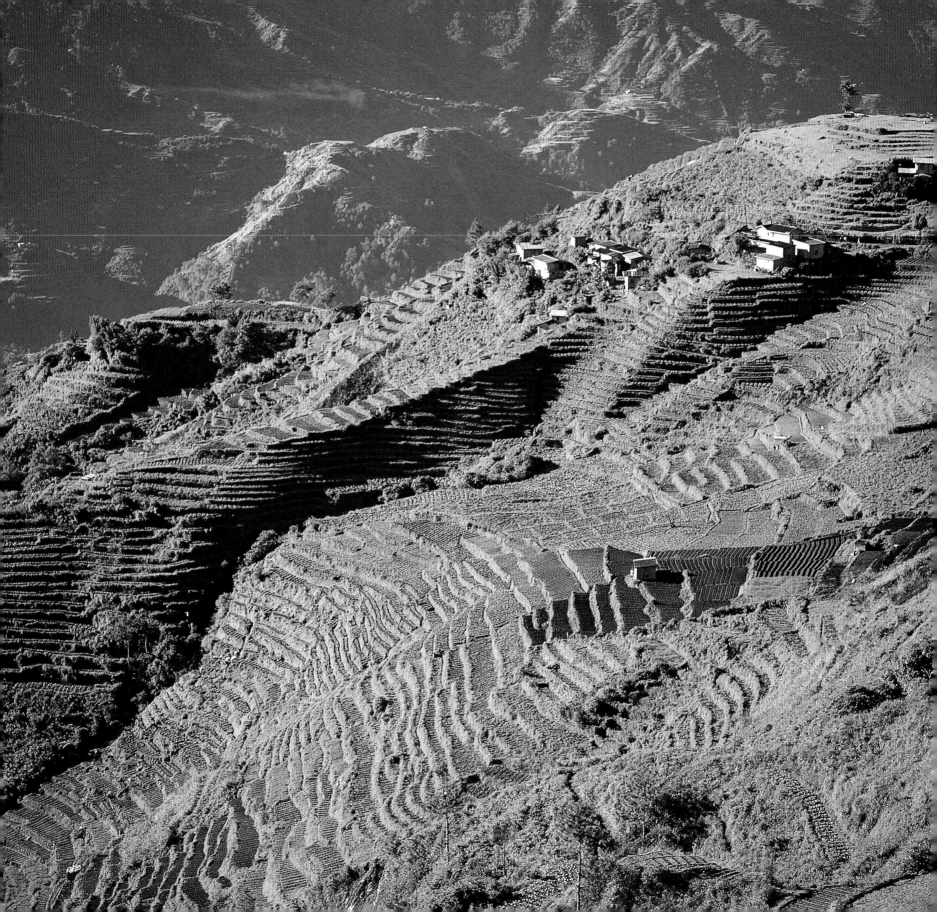

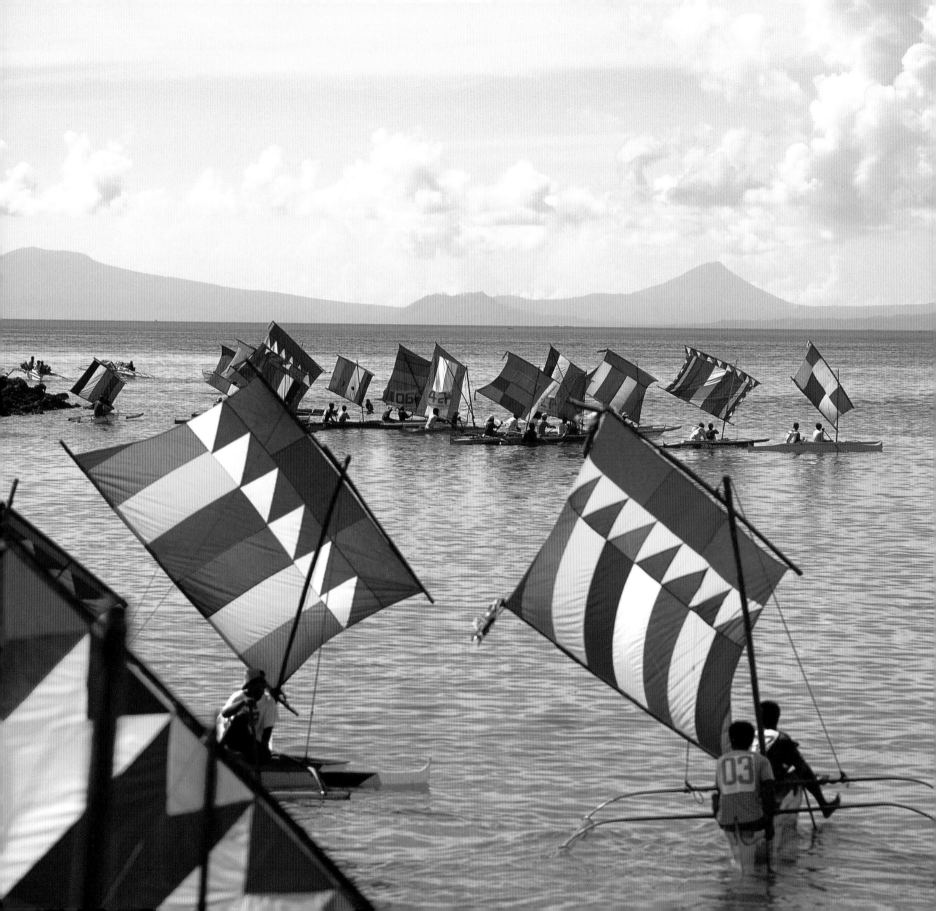

created from gradated embankments of packed mud form amphitheaters fed by gravitational irrigation. All over the mountainous area, too, pole-and-vine bridges arch gracefully over pristine creeks and rivers.

In the summer the loincloth-clad old folk – bird beaks and red ti leaves adorning their headdresses – shimmy down the terraces in single file while beating on wooden instruments to exorcise all rodents. It is as much a practical custom as one that must be handed down to the next generation as a traditional ceremony that will continue to bind the isolated community. The indigene's way of life must stay despite all manner of encroachment from the so-called civilized folk of the lowlands.

In the neighboring trade center of Bontoc, and in the pretty mountain hamlet of Sagada, the rice terraces may seem less grand, but assume a more picturesque character for their intricately riprapped stone walls. Vegetable gardens catch the eye, too, as vivid geometrical plots with raised beds that create surprising patterns of loops and whorls.

Idyllic Sagada's curious karst formations – a virtual stone forest of craggy limestone towers – rival the pine stands and waterfalls. These rocks also conceal a network of caves, some of which serve as repositories for log coffins stacked up in various burial chambers.

Another Cordillera tribe has kept priceless specimens of age-old mummies in their caves. The antiquated mummification process has long been lost; so too some specimens that have turned up in museums abroad.

Scientific evidence indicates that the entire Cordillera range (which includes the 2,150-meter-high Mt. Pulag, the second

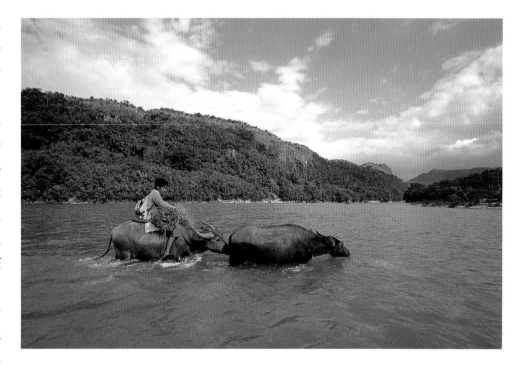

highest mountain in the country), sprung up from the seas eons ago. When the land emerged from the waters, it was still linked to the Asian mainland. Skeletal remains of a pygmy elephant found in the Cagayan Valley adjacent to the Cordillera prove that land bridges served as the link between the continent and what eventually became, when the waters flooded anew, the Philippine archipelago.

At well over 2,400 meters, volcanic Mt. Apo is the highest mountain in the southern island of Mindanao, which is itself closer to parts of Indonesia than to Luzon. Between Luzon and Mindanao are the major Visayan Islands, while southwest of Luzon are the large if marginal islands of Mindoro and Palawan. Clustering here and there as satellite isles are the rest of the archipelagic configuration of over 7,107 islands, "give or take

Opposite: The *vinta's* colorful geometric sails belie its swiftness and maneuverability in the seas off Mindanao. Here a flotilla with two-man crews prepares for a regatta. **Above:** The trusty beast of burden is the carabao or water buffalo, related to the *anoa* found elsewhere in Southeast Asia.

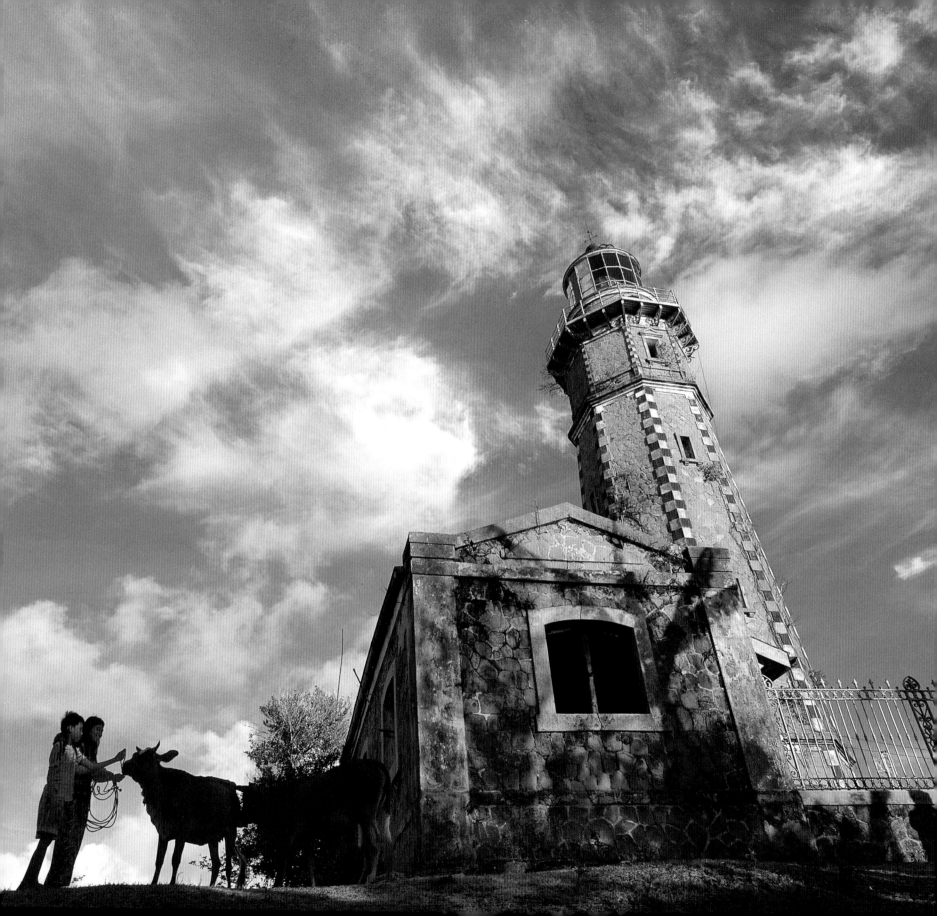

a few, depending on the tide," as Filipinas competing in international beauty pageants often quip to promote their country.

Stretching 1,840 kilometers from north to south and spanning 1,104 kilometers at its widest point, this series of half-drowned mountain ranges used to extend from Indonesia to Japan. The tiny island of Y'ami in the Batanes group is only 241 kilometers south of Taiwan, while Saluag island in the Tawi-Tawi group is only 48 kilometers east of Malaysian Borneo.

Less than 10 percent of the 7,000-odd islands are inhabited, with the 11 largest islands accounting for 96 percent of the total land area of 300,780 square kilometers, 65 percent of which is taken up by Luzon and Mindanao, which also contain 60 percent of the country's population.

The volcanic origin of the archipelago establishes it within the Pacific Ring of Fire. In 1991 the massive eruption of Mt. Pinatubo in Luzon broke a 600-year dormancy. Earthquakes are a daily given.

Typhoons from the Pacific Ocean batter the eastern coast of Luzon and the Visayan Islands from July to November before moving northwest to Taiwan, Hong Kong and Japan. The rest of the year is considered the dry season, with humidity rising in the summer months of April and May, while ideal, breezy weather is enjoyed from December to February.

Left: On Balabac Island off the southernmost tip of Palawan, a boy feeds livestock in the shadow of a colonial lighthouse with coral walls. Lighthouses all over the archipelago are another colonial legacy and serve as points of interest for travelers.
Right: Beachcombing on Unok Island, Balaba.

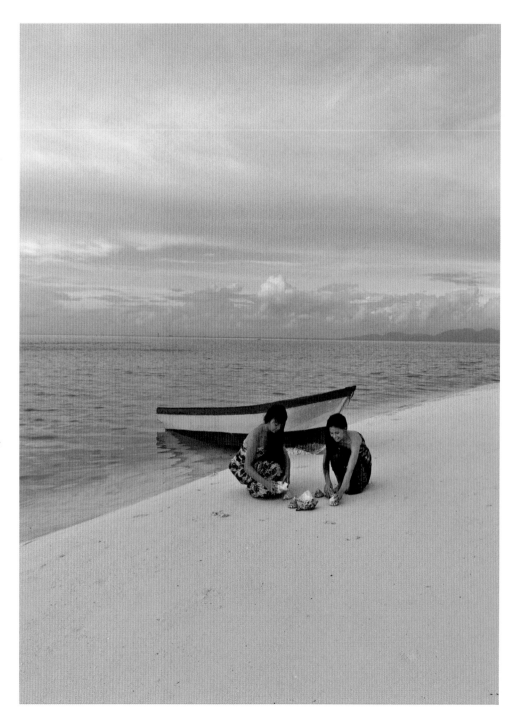

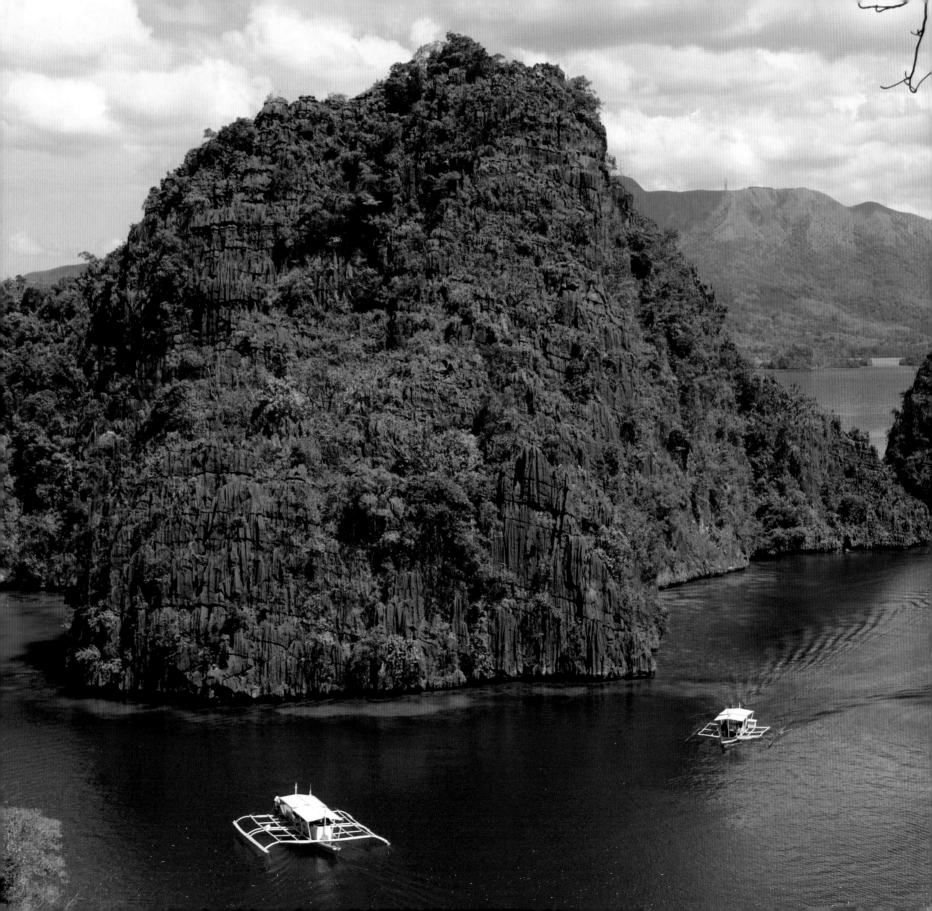

Biological diversity is rich throughout the archipelago, with plant and bird species among the most varied and endemically privileged in the world. The isolated island of Palawan hosts certain species found nowhere else in the country – such as the Palawan mousedeer, Palawan pheasant, flying lemurs, porcupines, skunks and anteaters – while only in an upland area on Bohol Island in the Visayan group may be found the endangered tarsier, a tiny, monkey-like primate with bulbous, pleading eyes that can sit on one's palm. Between Palawan and Luzon, Mindoro Island alone has the fabled *tamaraw* – a smaller cousin of the domesticated carabao or water buffalo, but which has remained wild and distinct with its straight horns.

Another endangered species that has justly merited an internationally funded conservation effort is the Philippine eagle, the reviving numbers of which soar only above the jungle fastnesses of southern Mindanao.

Along parts of the Philippine coastline, a shore that locals like to say is twice as long as that of the United States, there are mangrove swamps. And where they still haven't been tragically decimated for conversion into fish or prawn ponds, the underwater world they feed is something to behold.

One of the tiniest fish in the world is caught by the handful – only in Lake Buhi on the Bicol Peninsula, the southeastern tail of Luzon. In the Visayan Sea and all around the various straits and channels at the center of the archipelago, varieties of whales and dolphins, together with the dugong, or seacow, delight cruise participants on eco tours.

For those seeking more sedentary relaxation, paradisiacal conditions prevail in most beach resorts. In these island havens the pace of life contrasts greatly with that found in the highly Westernized capital cities. In the coastal areas, one may still revel in the daily rites that ruled the islands from time immemorial, albeit with the advantage of modern-day amenities.

Sun-bronzed men still shimmy up towering coconut trees to extricate the sap for native wine, while the women may be found along streambeds pounding away at their laundry with wooden mallets.

Fishermen take their individual *bancas*, those dugout canoes with bamboo outriggers, out to sea on moonless nights. By daybreak women and children waiting along the shore will form a fascinating spectacle as they help haul in the vast net laid out

Opposite: Dramatic limestone cliffs rise directly from the sea on Coron Island, off Palawan.
Below: An aerial network of bamboo poles serves a coconut sap gatherer for the daily extraction of fresh tuba or coco wine. When left to ferment, the wine turns to vinegar.

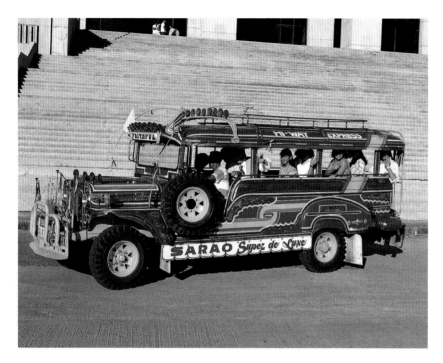

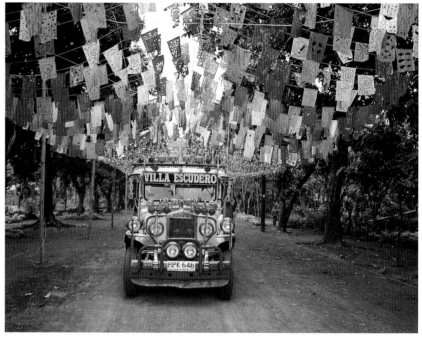

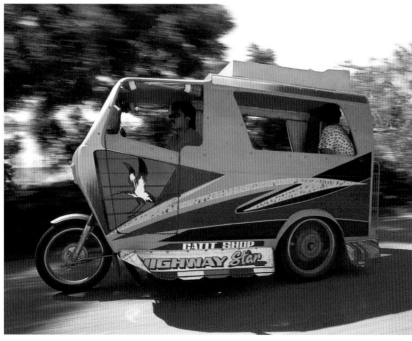

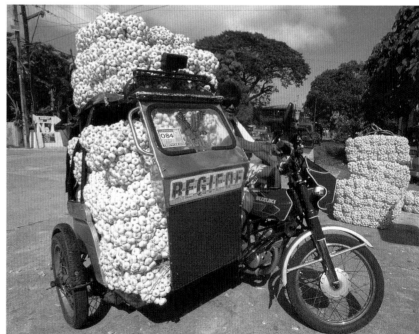

by scores of *bancas*. It's as timeless an exercise as it is a communal ceremony that bonds village after coastal village. These barrios are politically termed as a *barangay* – after the large boat known in pre-Spanish times as *balanghai*. Seafaring migrants once used these to reach the islands from other parts of Southeast Asia.

Once the land bridges to Asia had sunk, the "wave theory" of migration would have Indonesian settlers pushing north to occupy the rugged terrain of the Cordillera, followed by waves of Malay adventurers who settled on the coasts of the Visayan Islands, pushing the smaller, darker-skinned, and less equipped aborigines into the hinterlands. Thus, before the Spanish arrived to take advantage of the fragmented fiefdoms farther north, Islam gained a toehold in southern Mindanao. Although a Muslim fort had been established in the trading center later to become Manila, this proved easy picking for the conquistadors. Only the Muslim communities in southern Mindanao, as well as those in the scattered islands farther south, remained unconquered.

Such is the archipelago "where Asia wears a smile", and occasionally a frown over its many puzzling extremes and continuing contrariety.

Left: The common mode of public transport for short routes is the gaily-decorated jeepney, which manifests the Filipino's penchant for florid embroidery. Even the lowly motorized tricycle assumes various sizes and shapes in the provinces, where it is also used to haul modest cargo.
Right, top: The *calesa* or horse-drawn rig is still very much in use in the sleepy town of Vigan, northern Luzon, where it blends with the preserved colonial ambience.
Right, bottom: Negotiating his way through sugarcane fields is a masked reveler on his way to the *Masskara* festival in Bacolod City.

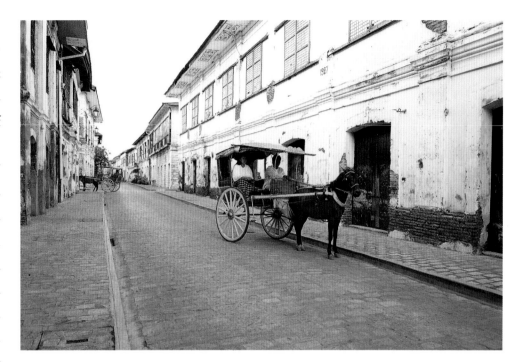

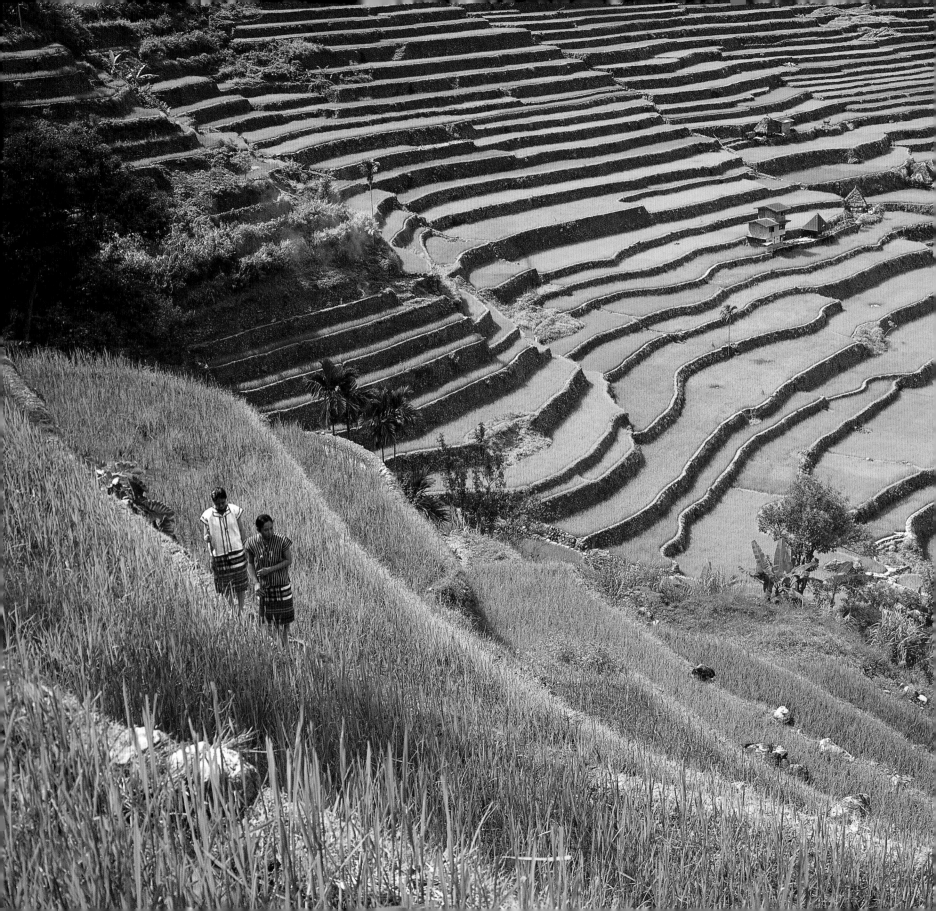

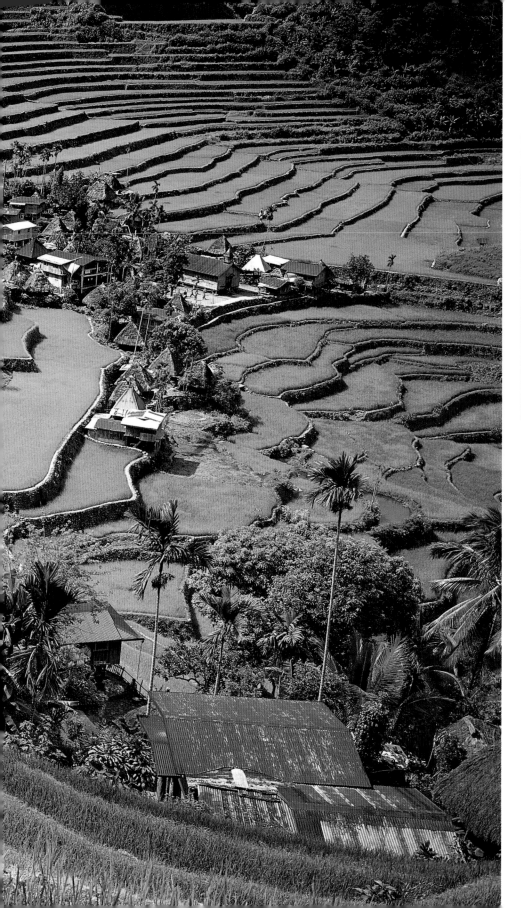

Left: Highland villages nestle amidst the expansive Battad rice terraces in northern Luzon. The Cordillera mountain range offers a salubrious climate, awesome vistas, and traditional daily rituals practiced by proud indigenous tribes. The town of Battad may be reached by a short ride and trek from Banawe, the capital of Ifugao province.
Above: A jeepney traverses a wide plain converted into a pineapple estate in Bukidnon province in northern Mindanao.

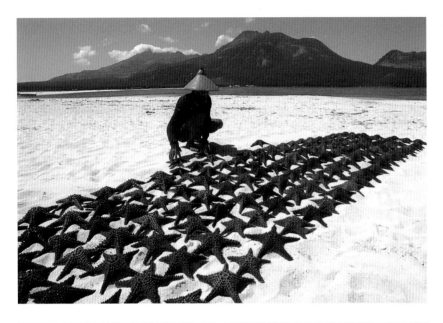

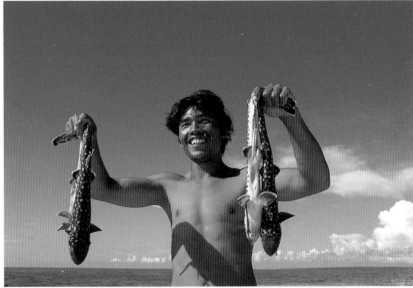

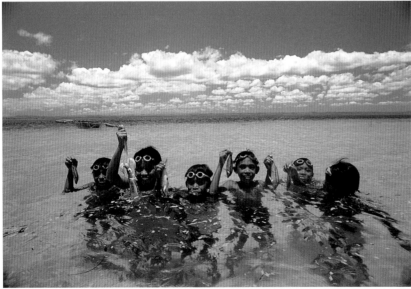

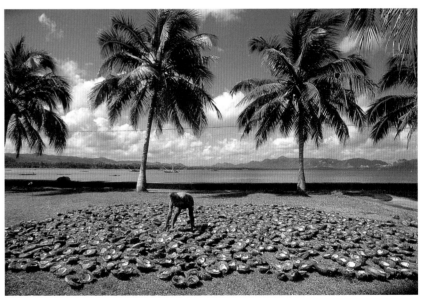

Above: Subsistence on natural resources is the name of the game all over the islands. Starfish are laid out to dry on a beach in Camiguin Island. A fisherman displays his catch, as do young boys relying on makeshift divers' goggles to plunge into the sea. A farmer also trusts the sun to dry coconut husks for copra, from which coconut oil will be extracted.

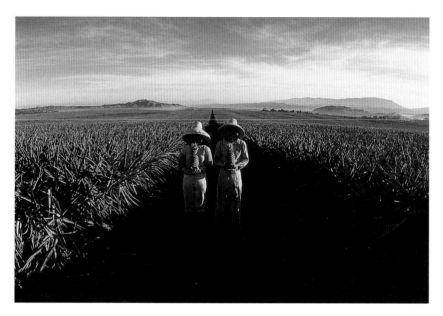
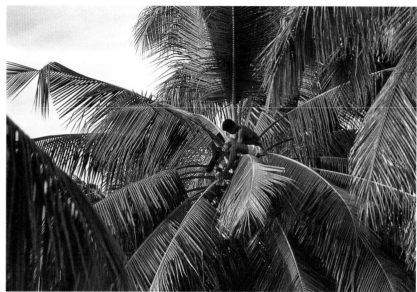

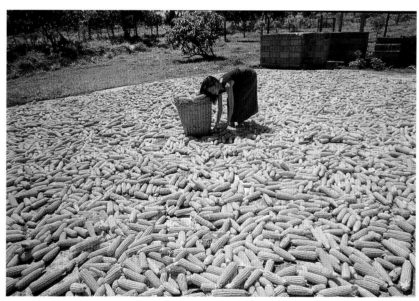

Above: The principle of living off the land can range from labor participation in a highly-commercial enterprise such as the vast Del Monte pineapple plantation in Bukidnon, or conducting small-scale if widespread village industries involving the coconut, the "tree of life". The other agricultural staple is corn, a harvest of which is laid out to dry before being processed into animal feed.

"Being a mother is a bedrock of strength for the Filipina through all change and conflict. Other institutions in her society reinforce its importance. The cult of the Mother of God continues to inspire many Filipinos who see in her a vivid symbol of these aspirations."

— Lourdes V. Lapuz, *Being Filipino*

HIGH SPIRITS AND HOLY DAYS

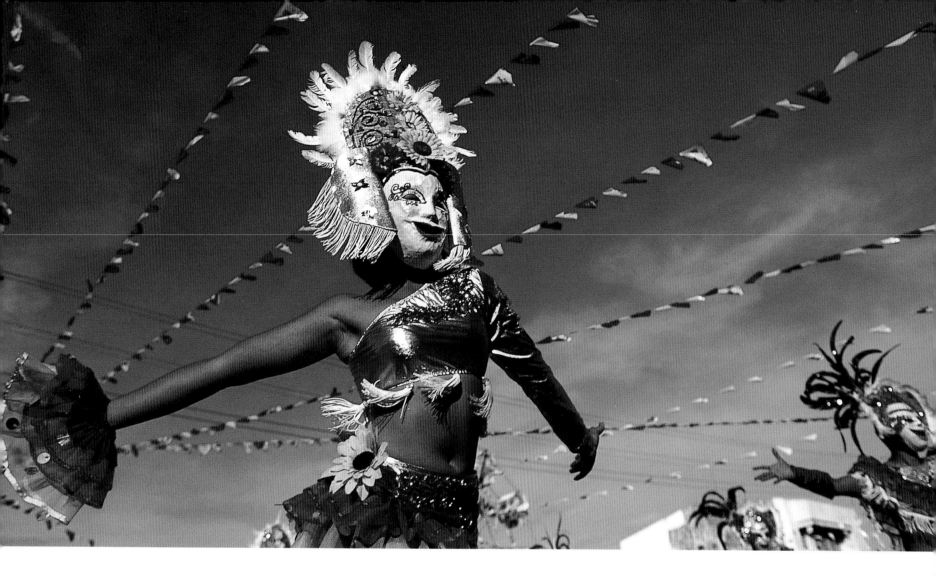

In a country redolent with festivities, Holy Week in the Philippines provides peak experience for ritualists and observers alike. In Pampanga province north of Manila, over a dozen Filipinos, recently including a woman or two, are literally crucified at three in the afternoon on Good Friday. Crowns of thorns are pressed on their heads, nails hammered through their palms and feet, and the wooden crosses they have borne on their shoulders to the site – hillock or plain – are hoisted up for the grand line-up. Observing the spectacle are fellow penitents, documentary media, the usual gaggle of street kids, and local and foreign tourists. Frowned upon by the Roman Catholic Church but encouraged by local politicians and tourism officials, this mass edition of a crucifixion proves nonfatal, as the volunteers hang on their respective crosses for an hour at most.

This annual ritual is the climax of long days of soul-searching and other gory acts of penitence. From Palm Sunday onwards, hundreds of self-flagellants trek on the highways leading north from Manila, or crisscross the byroads, beating their naked backs with leather thongs that end in all sorts of spikes.

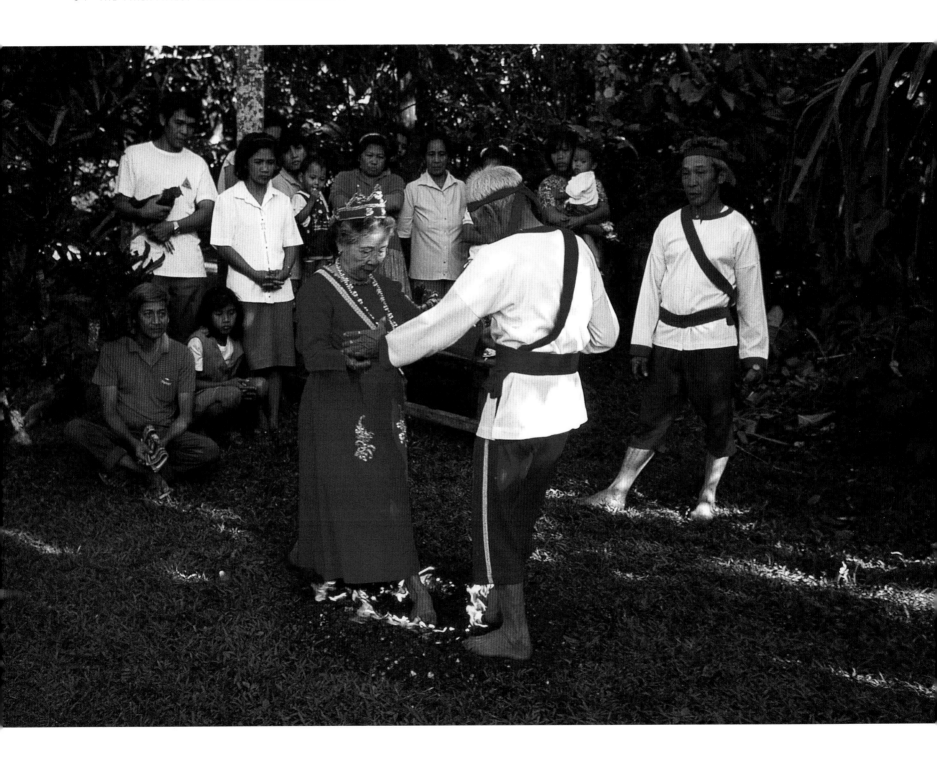

On Mt. Banahaw, pilgrims hike up the hallowed trails, making stops at appointed sites with names like the Cave of God the Father, Jesus's Footprint or the Cleansing Falls. On other parts of the sacred mountain that overlooks the provinces south of Manila, men gather to test their amulets. Blades and guns attempt to disprove the merit of rites and prayers, the latter featuring esoteric phrases in pig Latin.

On Marinduque Island south of Luzon, the *Moriones* festival draws a horde of visitors to witness a pageant that includes Christ's crucifixion, but climaxes with the chase of the Roman centurion, Longinus, all over town and across a river, until a mock beheading takes place. Everyone who has a role in the spectacle is appropriately costumed, with hand-carved wooden masks covering their faces.

Holy Week serves to start up the Philippine summer. Many families return to their hometowns or flock to the beach and mountain resorts. All other activities seem to come to a stop, especially during the long holiday from Maundy Thursday to Easter Sunday. Religion, mysticism, entertainment and occult practices all come to a head on Good Friday. Upon Christ's Resurrection, religious processions called *salubong* (meaning "meeting")

Previous page, left: Electric webs of intricate lights form the Christmas lanterns of San Fernando, Pampanga.
Previous page, right: Revelers from the *Masskara* festival of Bacolod City.
Left: Fire-walking is a quaint tradition in the town of Alfonso, south of Manila. A troupe of firewalkers is occasionally commissioned to perform their homegrown rites at hotel lobbies in the lake-view resort city of Tagaytay close by.
Right: Mt. Banahaw, an extinct volcano southeast of Manila, is regarded as a sacred mountain. Pilgrimages are conducted during the summer months, especially during Holy Week.

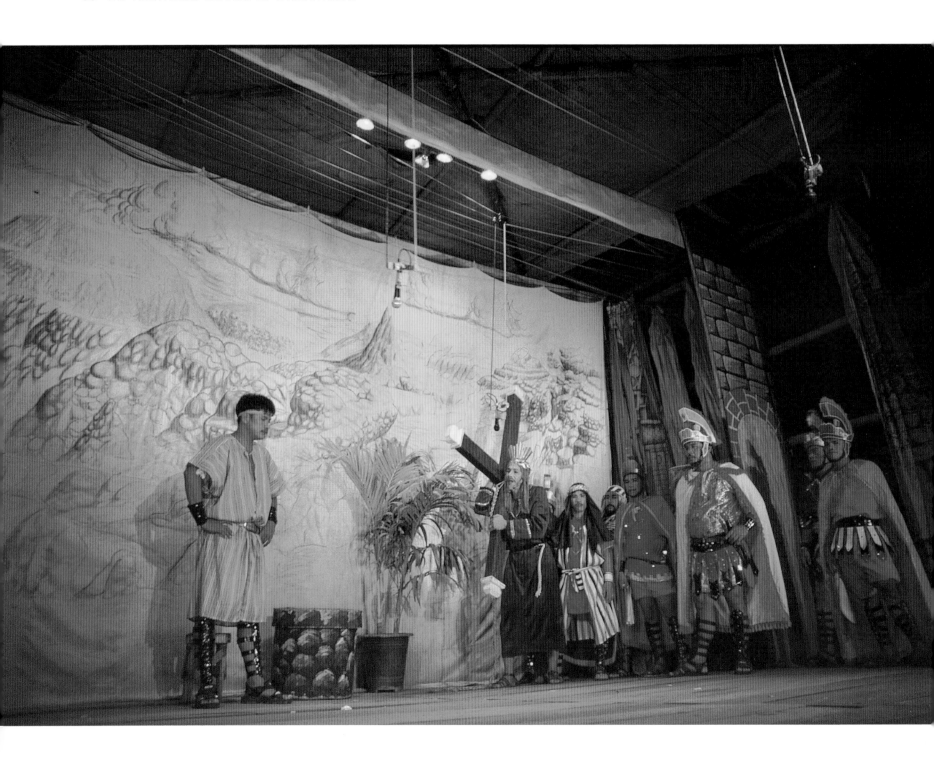

are conducted. The figure of Christ borne on a *carroza* or carriage meets the image of the Blessed Mother in the town center.

Like most of the fundamental requisites in these rituals, the colorful buntings that hang high across the streets are carry-overs from the days of Spanish colonization. These have all assumed a local character, with indigenous customs finding a way to merge with Christian tradition. Then, of course, there is the matter of modernization. The candles and torches that used to illuminate *carrozas* have been replaced by light bulbs powered by portable generators. In the case of the buntings, what used to be colored slips of paper have given way to an array of commercial advertisements.

May is fiesta time, celebrated with merry abandon. Every self-respecting town sets aside a day for its fiesta in honor of its favored saint. Bedecked with buntings and other picaresque displays, the streets are pervaded with a carnival atmosphere – a tropical celebration of summer, where the prize to honor or pray for is a bountiful harvest.

Homage is paid to the carabao or water buffalo – the beast of burden that is the farmer's best friend. In the old town of Pulilan in Bulacan province, (Manila's closest northern province, and the seat of Tagalog pride and intellect) the carabaos are

Left: Depicting the tribulations of Jesus Christ on his way to Calvary, the *Cenaculo* is a stage pageant performed before a town audience during Holy Week.
Right: On roads and other public places in central Luzon, Holy Week is marked by self-flagellation among a virtual army of penitents. This also leads to actual instances of crucifixion on Good Friday. The Roman Catholic Church frowns upon the gory spectacle, but can't do anything to eradicate these dubious highlights of tradition-bound "folk Christianity" for they have also become a tourist attraction.

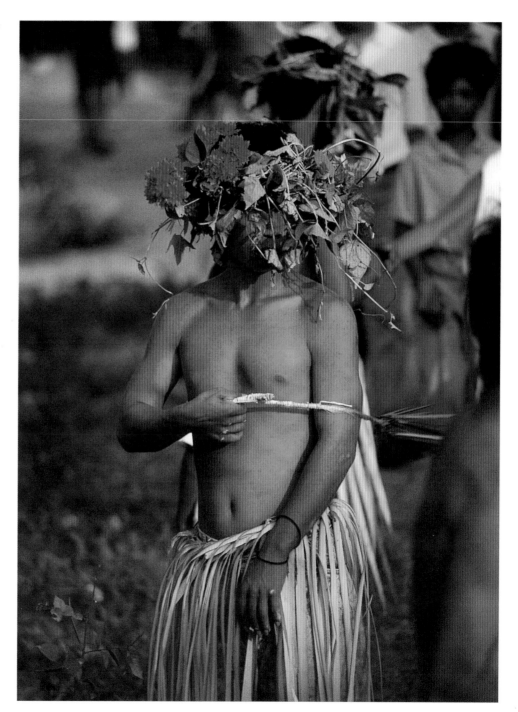

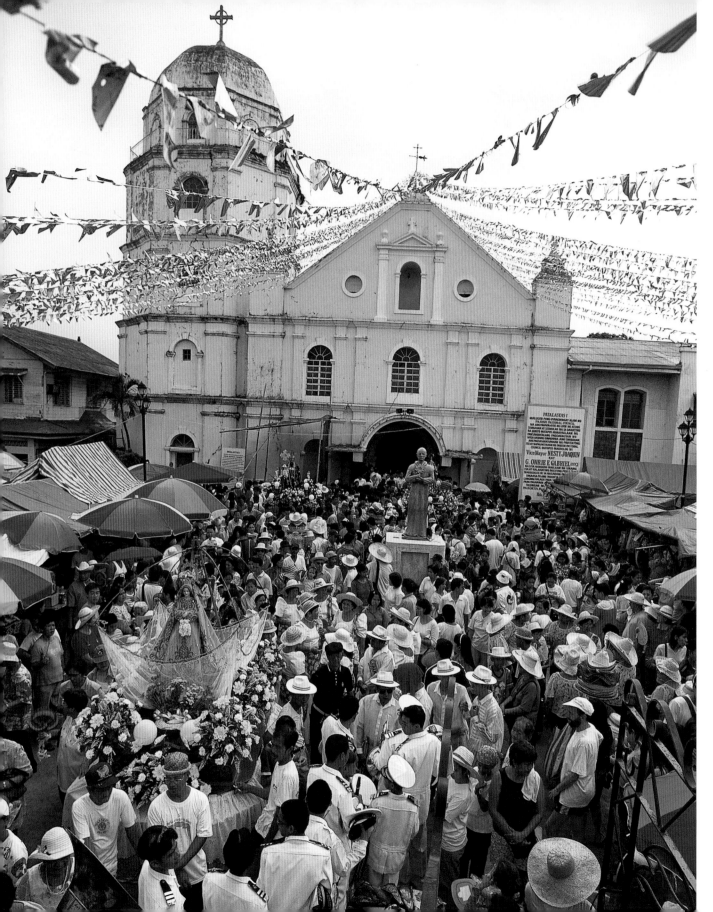

Left: The church courtyard in Obando, Bulacan province, north of Manila, marks the start of a religious parade honoring the town's patron saints. The day will also see crowds of womenfolk dancing in the streets in a fertility ritual. Symbolically, they will implore all the saints to bless them with childbearing capability.
Opposite: The menfolk of Cebu appropriate the responsibility and privilege of bearing Marian and other Christian images whenever it's a day for a religious procession or festival.

scrubbed clean and dressed up or painted prior to being paraded before the church. They are also made to kneel before an image of San Isidro Labrador, the patron saint of farmers, on his feast day of May 15.

Similar festivals honoring San Isidro are held in Quezon province, another cradle of Tagalog pre-eminence but one laced with more mystical strains compared to Bulacan's revered rationalism. In Gumaca it is called *Arana't Baluartehan*; in Sariaya, *Agawan*; in Tayabas, *Mayohan*; and in Lucban, *Pahiyas* – by far the most popular. Houses and streets are decorated with a multitude of farm produce. Fruits and vegetables hang from windows or decorate an awning or balcony in a cornucopia of natural delight. The staple grain, rice, is turned into a thin wafer shaped like a leaf, painted in marvelous colors, and strung up to form cascading patterns. These can wrap entire houses in a blaze of iridescent hues.

The summer fiestas are capped by the *Santacruzan*, the queen of Maytime festivals, which also involves a pageant and a candle-lit procession but with religious overtones. This is a grander version where the participants represent certain Biblical and mythological characters such as *Reyna Elena*, Queen Helena, with her young consort Constantine. Again, ornate gowns come into play; wealthy families vie to have their debutantes and matrons play parts in this extravaganza.

The calendar of festivities throughout the archipelago starts as early as January, when the Feast of the Nazarene is played out in the busy district of Quiapo, in downtown Manila. An all-male throng assembles before Quiapo Church, where the larger-than-life-sized ivory figure of Jesus of Nazarene, bearing a

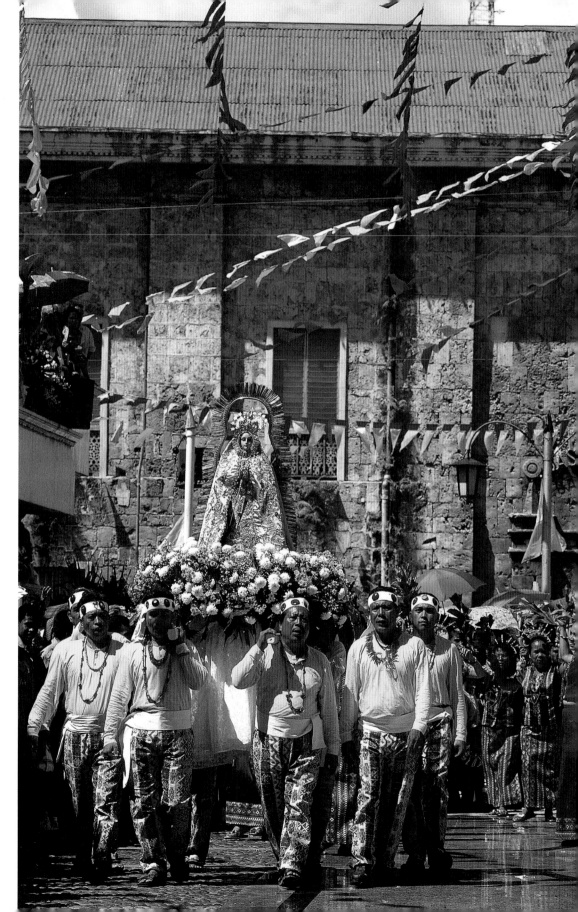

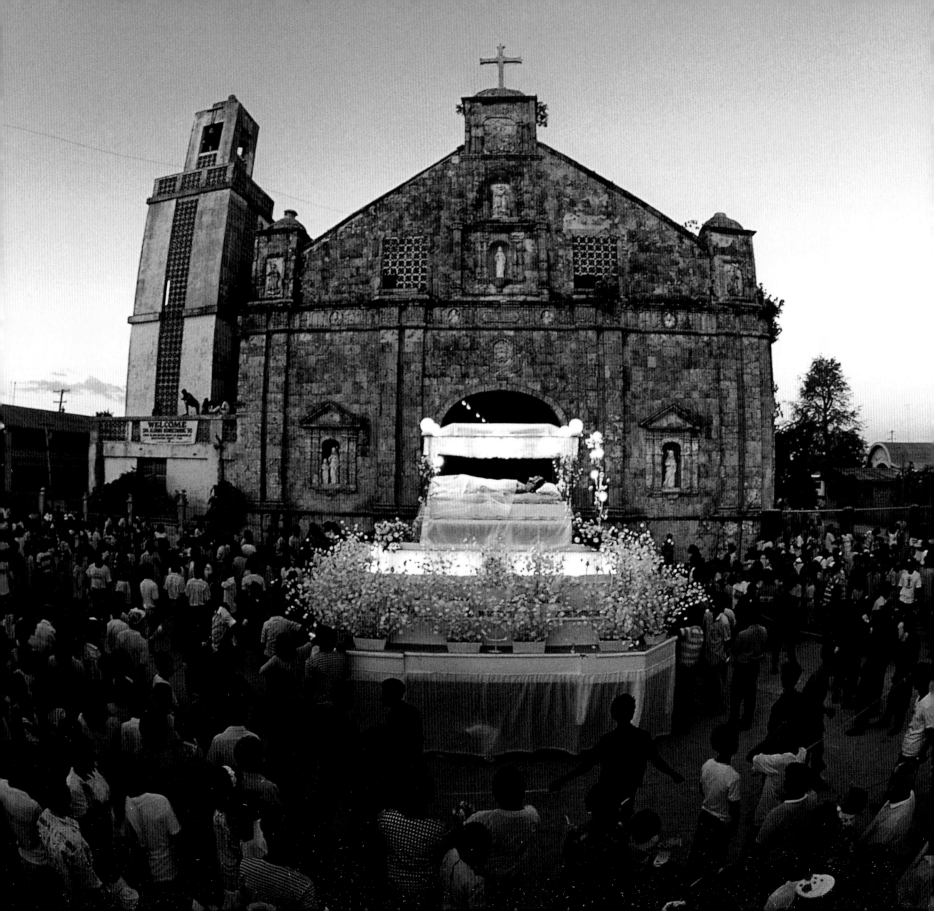

heavy cross, is brought out on a large *carroza*. It is an honor to be one of the score or so of male devotees allowed to ride atop the carriage, and a lesser privilege to be among the two lines of men that pull the ropes to advance it. Along the way, parts of the brawny crowd surge closer to the object of veneration as it moves along and offer their handkerchiefs to swab a part of Christ's figure. The men atop the *carroza* do this service, and quickly fling back the handkerchiefs to their owners. A moment of weakness usually causes someone to be trampled underfoot. Inevitably, hundreds of photographers and cameramen cover this annual January 9 event. All of Quiapo goes on holiday, as the macho spectacle is documented for its inimitable scenes of religious frenzy and mob motion.

By the third weekend of January, the shutterbugs move en masse to Kalibo on Panay. Here the *Ati-Atihan* festival, referring to the dark-skinned aborigines called *Ati* or *Aeta*, relives the legendary Barter of Panay Island. As pre-Hispanic lore goes, the pygmy-sized natives gave up their coastal lands to the seaborne migrants from Java's Madjapahit Empire – in exchange for a golden hat.

Elaborately costumed groups of revelers, faces blackened with soot, snake-dance through the streets to thumping syncopation and shouts of *hala bira!* The Mardi Gras-type revelry takes three full, orgiastic days of dancing, drinking and merriment. This festival has been replicated in other parts of the Visayan group. In Antique it is the *Dinagyang* festival; in Bacolod, the *Masskara*; in Cebu, the *Sinulog*, where the cries of *pit senyor!* pay tribute to the *Santo Niño*, Christ Child, whose image is carried along and danced with in the all-day carousal.

During other months (except for the rain-plagued season from July to November), further unique celebrations draw out-of-town visitors. There is the *Caracol* in Iligan in northern Mindanao; the *Pista ng Dabaw* or Feast of Davao in southern Mindanao, where the durian takes pride of place as the king of fruits in a harvest parade; the *Panagbenga* flower festival of Baguio City; the *Bangus* or milkfish festival of Dagupan in Pangasinan, where a kilometer-long line of charcoal-fed grills has sought to enter *The Guinness Book of Records*.

The town of Balayan in Batangas conducts its feast of the *lechon* or roast pig on June 24. Hundreds of these spit-roasted delicacies are borne aloft in a parade that climaxes with the

Opposite: A life-sized replica of the dead Christ is displayed before the church on Bantayan Island off Cebu.
Below: Cebu City's *Sinulog* festival honors the *Santo Niño*, Christ Child.

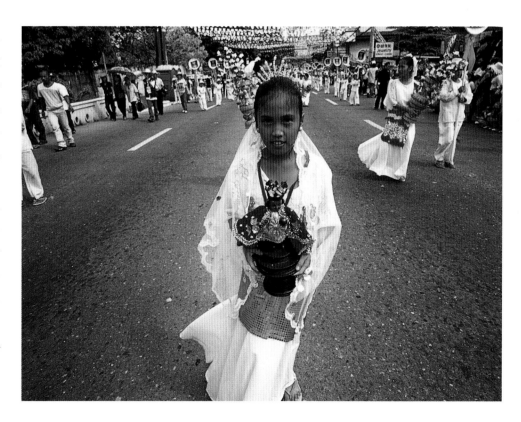

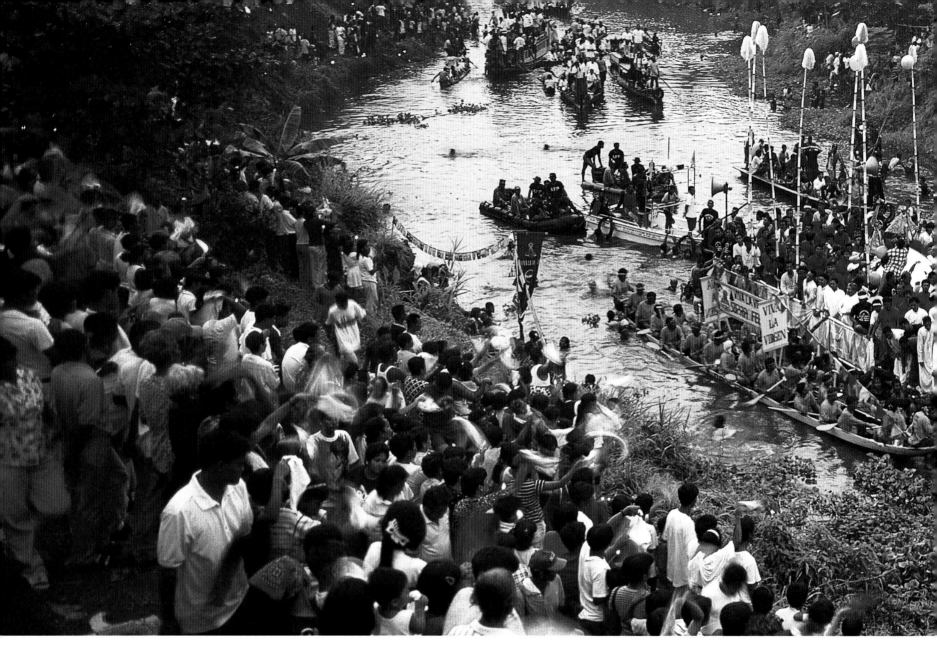

participants being doused with water. On the same day, the municipality of San Juan in Manila celebrates the feast of St. John the Baptist by engaging in similar, prankish activity. Everyone who go through town is splashed with water. Then there are the fluvial processions, the best-known being the Feast of Our Lady of Peñafrancia in Bicol, where the centuries-old image of the Blessed Virgin is venerated in a river-borne parade.

No greater fiesta is there, however, than the Yuletide celebration at the end of the year, reputed to be the longest celebration of Christmas anywhere in the world. It starts unofficially in early November, when familiar carols are played on the radio. The nine-day string of dawn masses starts on December 16, when all Catholics rouse at cock's crow to walk to the nearest church and begin commemorating the Nativity. After Mass,

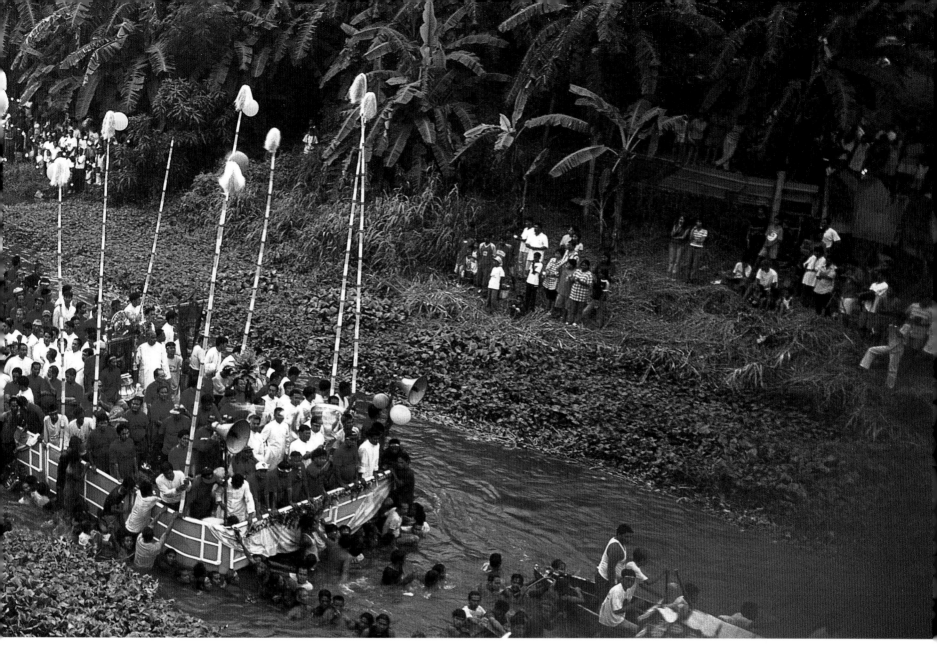

the custom is to partake of delicacies sold in stalls around the church courtyard. The daily *Misa de Gallo* is capped on Christmas Eve with the Midnight Mass, after which families go home for the *Noche Buena* or midnight meal before presents are exchanged and opened. The Christmas festivities don't end with the riotous fireworks displays or concatenation of firecrackers set alight by every household on New Year's Eve. Children can still look forward to the Feast of the Three Kings on the first Sunday of January. Another round of gift-giving victimizes the *ninongs* or godfathers.

In these islands, which seem to be perennially on holiday, everyone is a godfather or a godmother. And the offer to partake of a feast, or share in the gift-giving and surplus of goodwill, can never be refused.

Above: The image of Our Lady of Peñafrancia is among the most highly venerated in the islands. A fluvial parade of barges and boats in Legaspi attracts hordes of onlookers, many of them locals for whom the ritual is an annual homecoming.

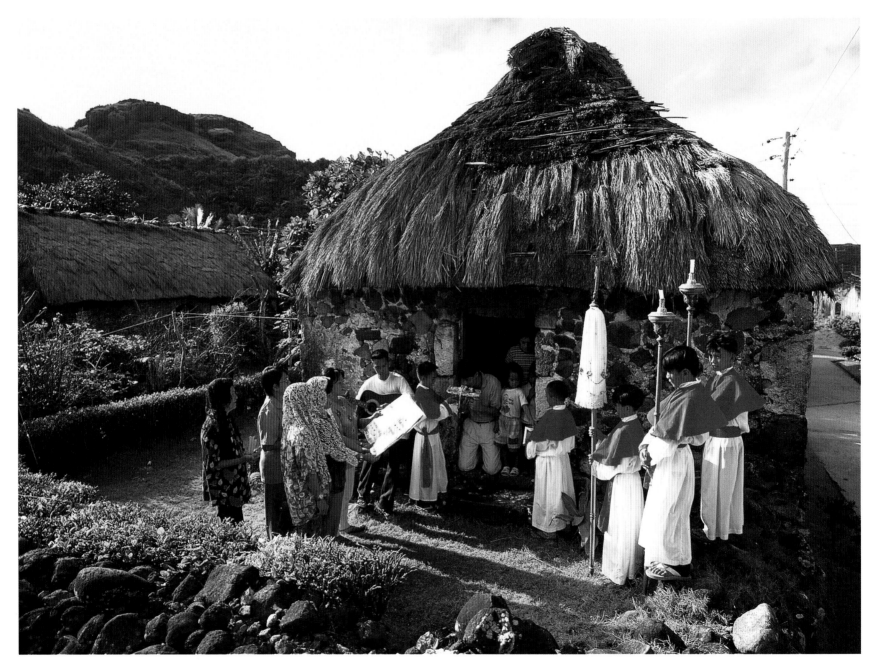

Above: A group of *sacristan*, acolytes, celebrate the Feast of the Three Kings by visiting residents in far-flung Sabtang Island in the Batanes, and having them kiss a *Santo Niño* image. They are accompanied by *cantores*, singing matrons. The typical, grass-thatched stone houses are sturdy enough to withstand seasonal typhoons from the Pacific.

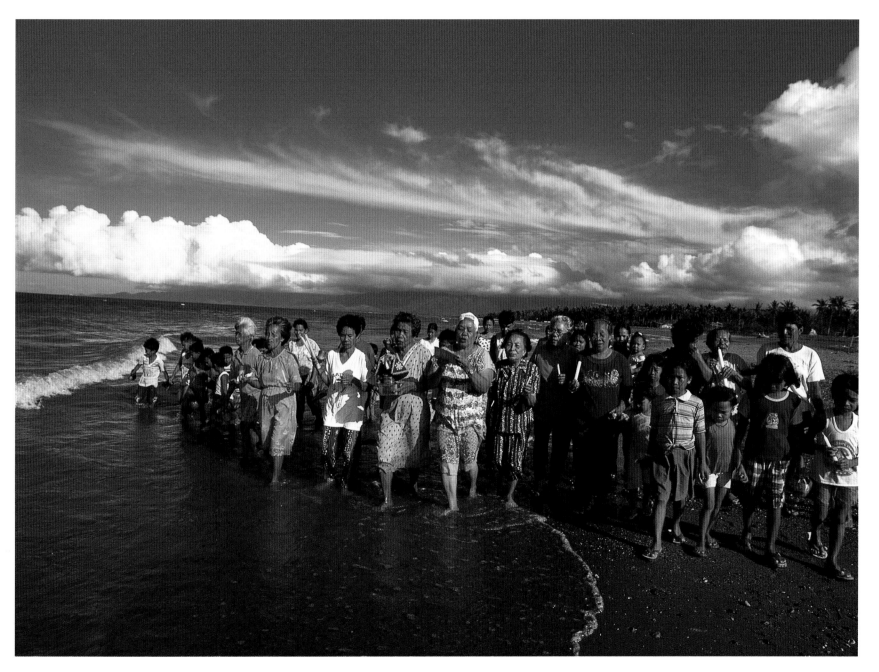

Above: In the coastal town of Ibajay in the Visayan Islands, the devotion to the *Santo Niño* takes a different form, as matrons and children conduct a procession along the shore in supplication of a consistent, good marine harvest for their menfolk.

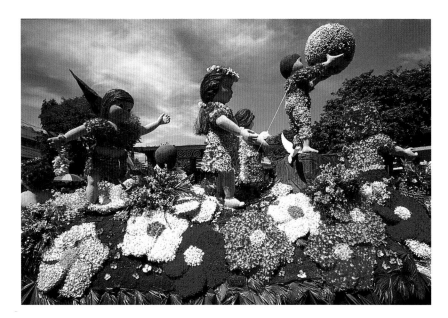

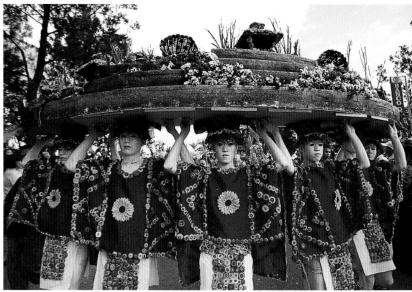

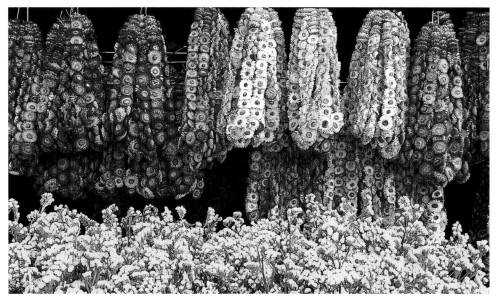

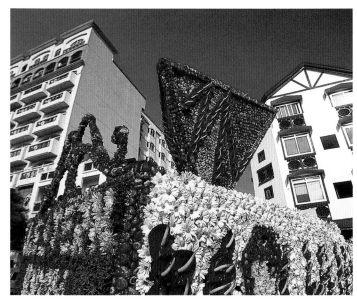

Above: Radiant colors and splendiferous forms make up a tropical country even in Baguio City, the "Summer Capital", which is exempt from the otherwise typically hot and humid climate. The *Panagbenga* flower festival that heralds summer is celebrated with a parade of floral floats. In the market, traditional garlands of everlasting flowers offer a popular souvenir buy.

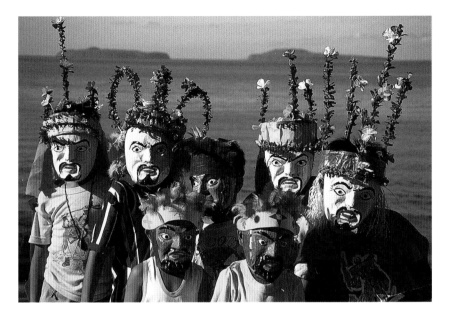

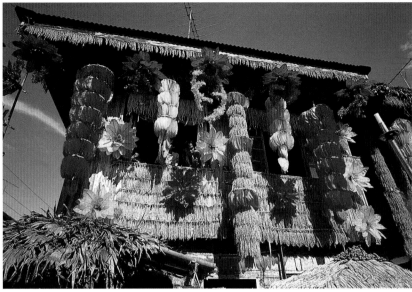

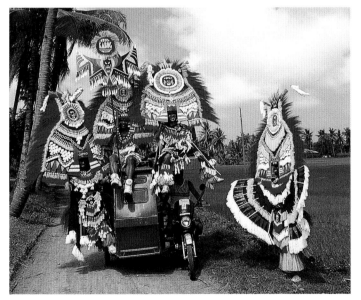

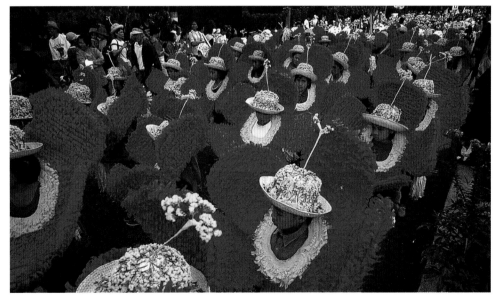

Above: Summertime means religious festivals galore. Distinctive wooden masks sprout all over Boac, Marinduque for the *Moriones* festival that re-enacts the crucifixion of Christ and its aftermath. Every house is festooned with farm products during the *Pahiyas* festival in Lucban, Quezon province, which honors San Isidro Labrador, patron saint of farmers. *Ati-Atihan* revelers load up on a tricycle before dancing on the streets for three full days in Kalibo, Aklan province.

"Filipinos love to embellish: houses, furniture, vehicles, clothes, knick knacks, anything and everything. *Horror vacui* . . . has been used to describe the Philippine decorative arts — it means, quite literally, 'the fear of empty spaces.' This tendency is not uniquely Philippine; in fact, the Filipinos' love for elaboration finds resonance in the decorative arts of their Southeast Asian neighbors and in the Baroque style introduced by Spanish colonizers."

— Rene Javellana, *Filipino Style*

A Penchant for Literature, Beauty and Art

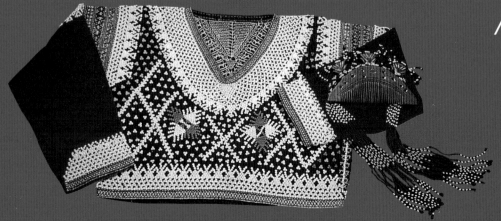

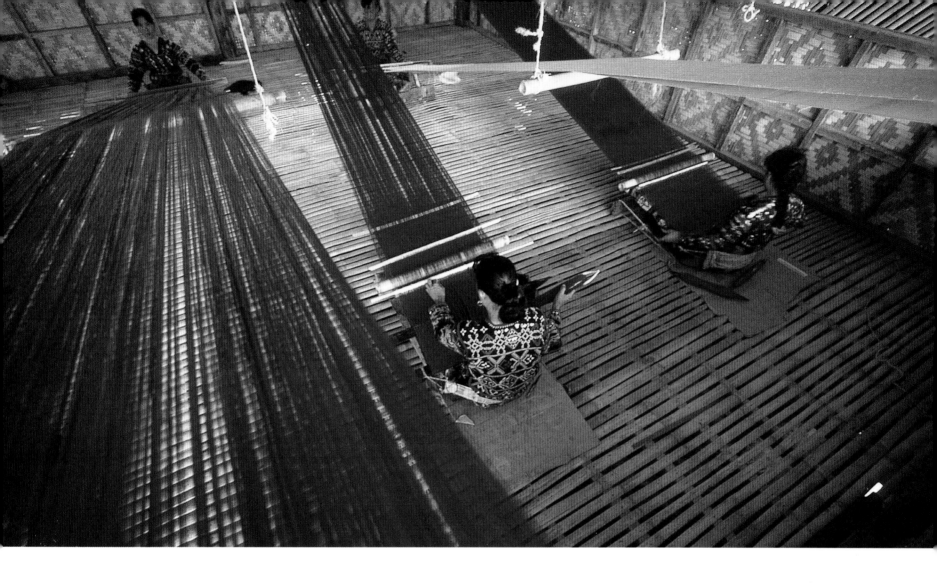

Mangyan tribesmen of Mindoro island, south of Luzon, still incise their poetry on bamboo tubes. The verse inscribed is of a form called *ambahan*, using the vernacular that is understood only by the few thousand that make up the cultural community, and perhaps a handful of linguists. Usually a love poem, it is then handed to the object of affection. But not much remains of any literature produced in pre-Hispanic times, except for the oral in the form of chanted epics extolling gods and heroes.

It wasn't until the mid-19th century that Filipino writers who had since been trained in the Spanish language would begin incipient attempts at producing literature, thus adding to the folk stories, riddles, proverbs and verse in myriad dialects.

Filipino *ilustrados* – those who had had the benefit of education and in particular the academic and propagandist exiles in Madrid and Paris – wrote essays to advance the cause of independence and nationhood. Dr. Jose Rizal's two novels, penned and published in Europe, became the epitome of Filipino writing in a non-native tongue, along with his numerous essays, scholarly commentary and rigorous correspondence.

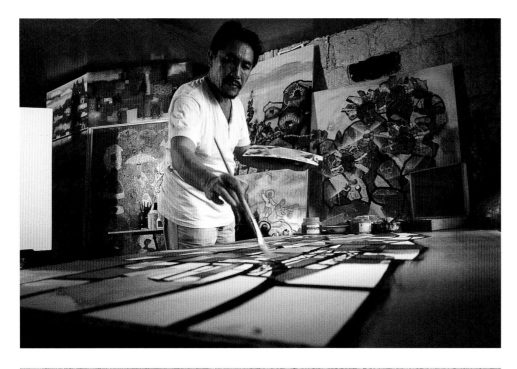

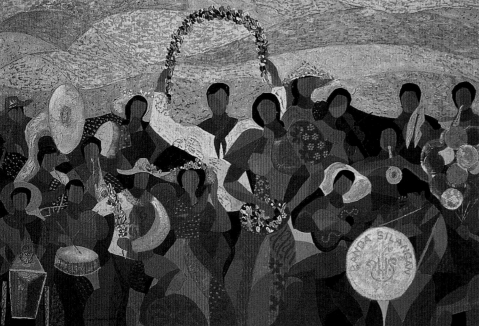

Filipino writers spent a brief period of tutelage in a new language – English as the American colonists taught it – before coming up with their first efforts at poems and stories at the start of the 20th century. Even though political independence was gained in 1946, nationalists only brought up the language issue in the 1970s. The Tagalog spoken in Manila and southern Luzon officially became Filipino, although the more populous Cebuanos in the south still resist its use.

Writers have been encouraged to produce work in the native language, and even regional languages and dialects have been revived for the production of literature. The great numbers of Filipinos living abroad, however, continue to expand the ranks of English-language writers, some even breaking geographical barriers by being published in the United States.

While the acknowledged English-language master among Filipino writers remains the poet, fiction writer, dramatist, essayist, biographer and journalist Nick Joaquin, his fellow National Artist for Literature, F. Sionil Jose (also based in Manila), is perhaps the best known abroad, his novels being the most widely translated into foreign languages.

Previous page, left: Ethnic wear turns resplendent with beadwork and geometric embellishments.
Previous page, right: T'boli weavers working with backstrap looms are among the most accomplished in Mindanao.
Left, top: Manuel Baldemor is one of the country's foremost painters. The prolific artist has sketched and painted scenes and landscapes of the world's most popular destinations.
Left, bottom: A Baldemor painting depicts the local tradition of music-making in his hometown of Paete by the lake, Laguna de Bay.
Right: Colorful jeepneys are among the favorite subjects for modern artists like Baldemor.

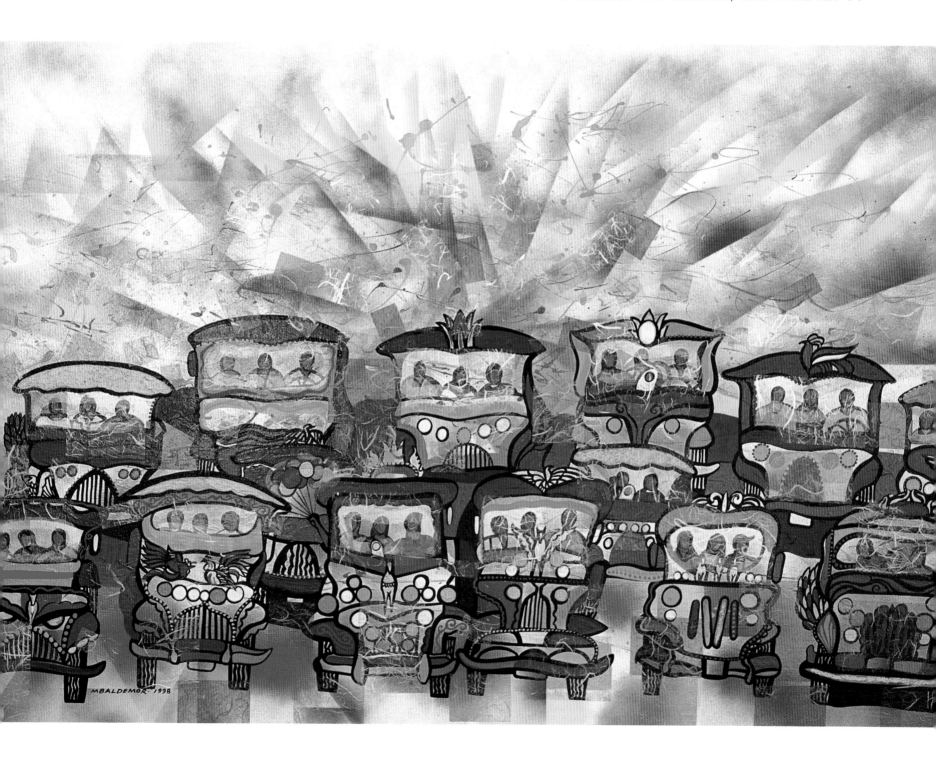

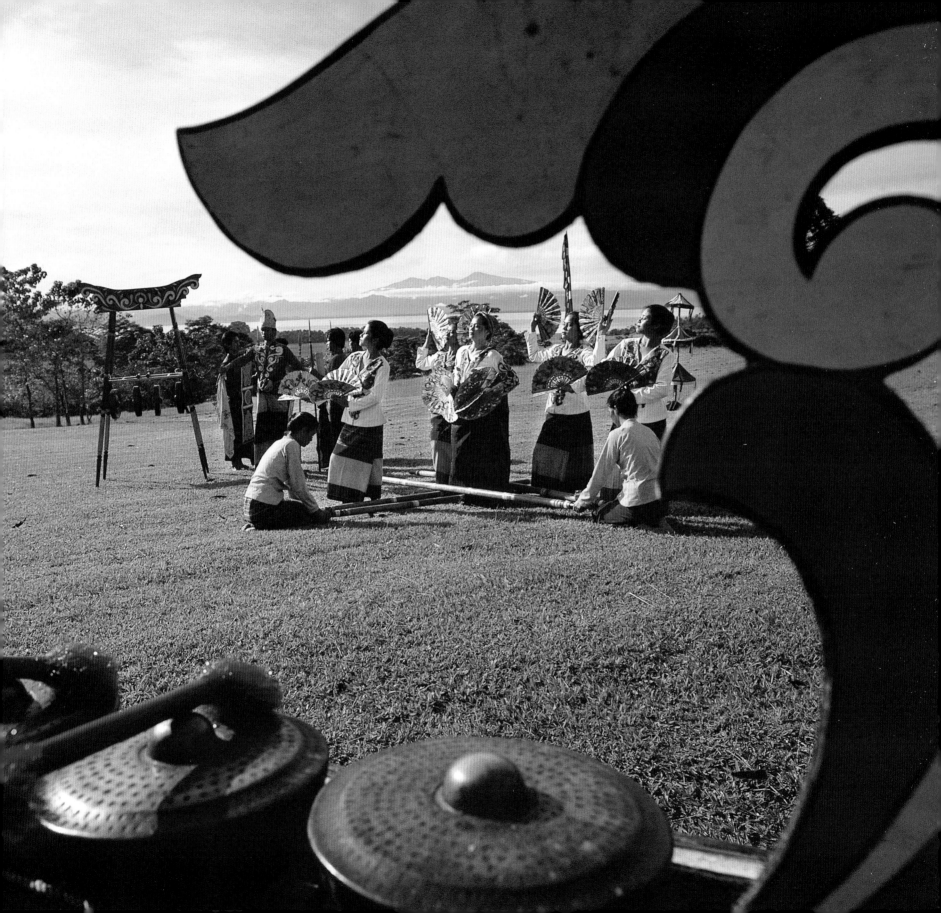

In America, Filipino novelists who have gained renown as part of the Asian-American literary juggernaut include Jessica Hagedorn, Ninotchka Rosca, Bino Realuyo, Eric Gamalinda, and the young Filipina-American Tess Uriza-Holthe who debuted with a bestselling first novel.

In the 1890s, Paris-dwelling Filipino painter Juan Luna, together with his fellow expatriate Felix Resurreccion Hidalgo, gained early international acclaim in the visual arts by winning prestigious contests.

Filipino visual artists continue to be among the top draws in auction houses that have only recently discovered the wealth of contemporary Southeast Asian art. The oil canvases of past masters like Fernando Amorsolo – who became prominent in the mid-20th century–command a high price as collectibles. Not far behind are the works of modern painters such as Anita Magsaysay-Ho, Bencab, Malang, and Juvenal Sanso.

The art scene in Manila has become so dynamic that renowned artists are increasingly fêted beyond their shores in cities such as Singapore and Hong Kong. The sculptor Eduardo Castrillo, glass specialist Ramon Orlina, and Imelda Pilapil are much sought-after for their work on public monuments and corporate lobby displays.

Left: A Maranaw dance troupe is framed by a typically Muslim wood-carving that arches gracefully over a row of brass gongs making up the *kulintang*, a percussion instrument. The dance is the *singkil*, performed with fans while tiptoeing gingerly through rhythmically crossed bamboo clappers. The setting is at the Mindanao State University campus which overlooks Lake Lanao.
Right: Composer and folk singer Freddie Aguilar has made a name for himself in Asia with his soulful ballads.

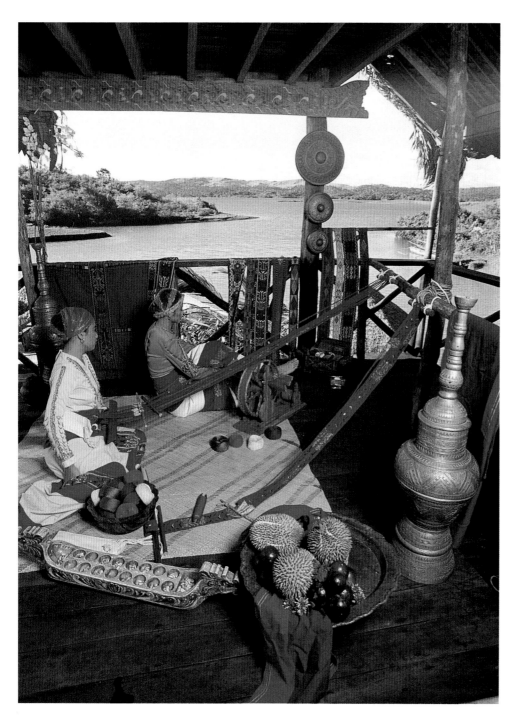

It is in the performing arts that the Filipino creative spirit commands a premium. Dance has long been a national medium of artistic expression. The Bayanihan Dance Company has toured world capitals for decades, performing to full houses appreciative of the elegant suites of traditional native and Castilian-influenced dances.

That the Filipino excels in music may be traced to the communal and national passion of expressing the soul by way of song. The brilliant classical pianist Cecile Licad, a child prodigy from Manila, now based in New York, has the pick of invitations for top-drawer concert tours and big-label recordings.

At the popular end of the musical spectrum is Lea Salonga, another *wunderkind* from Manila theater who went on to define the tragic Asian heroine in the West End production of *Miss Saigon*.

Filipino pop, rock and jazz bands are synonymous with first-class entertainment in international cruise liners and nightspots all over Asia; they have long been hailed as top-caliber entertainers for their professionalism, effortless reproduction and interpretation of Western music.

In the countryside, trust the Filipino to carry a guitar to the rice fields, and strike up rhythmic melodies to spur an army of planters on through the paddies. Elsewhere in the hinterlands, it could be the infectious rhythm of gongs and other percussion instruments that will strike up a tribal beat, or the plaintive

Left: The Maranaw, a royal class among the Muslims in Mindanao, employ their own style of weaving. Durian and mangosteen fruits, gongs and other brassware, a native mat and wood-carved receptacles comprise the exotic display in this richly adorned house in Marawi overlooking scenic Lake Lanao.

sound of the nose flute, up in the mountains, that will share the memory of keening sadness or the lyricism of desire.

Native crafts thrive in the provinces, where weavers and woodcarvers pass on their consummate skills from generation to generation to produce traditional, if commercial, items such as T'nalak cloth and alternate distinctive woven fibers, palmweave mats, hats and baskets, and other utilitarian items of furniture.

Folk art may also take the form of near-kitsch papier-maché figures, shellcraft, souvenir woodwork, beadwork, brass jewelry and assorted implements. Jeepneys and motorized tricycles all over the archipelago often bear the ornate flourishes characterizing creative folk expression.

The Filipino's innate sense of design has been much showcased recently. Some excellent examples have set a hallmark for interior decoration. Annual furniture shows and worldwide exhibitions provide the Filipino creative designer with an increasingly expanded arena of opportunity to convince international buyers that the Philippines can lay claim to being "the Milan of Asia".

The fashion designer, architect and filmmaker also contribute in carving out a distinctive name for Filipino art. Indeed, it can be argued that nowhere else in the region have prodigious traditions and modern savvy come together to form such dynamic creativity.

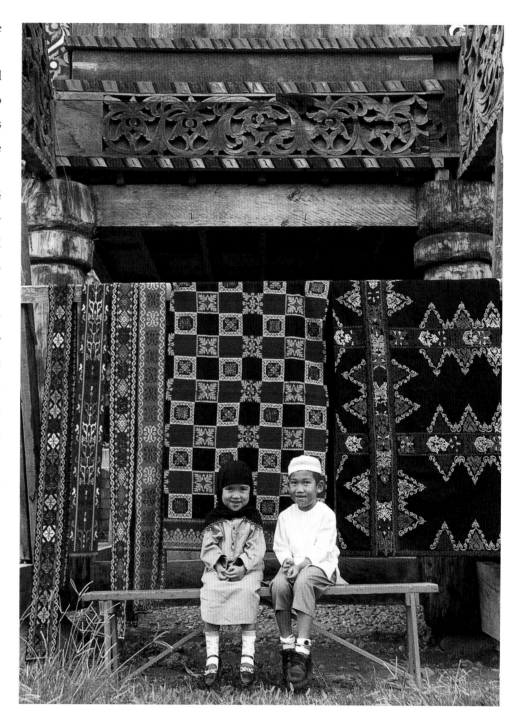

Right: Muslim children pose before an array of woven sashes, runners and blankets, all exhibiting distinctive geometric designs and strong colors used in the fabric dyeing process. Above them are typical architectural features such as hand-carved wooden columns and friezes.

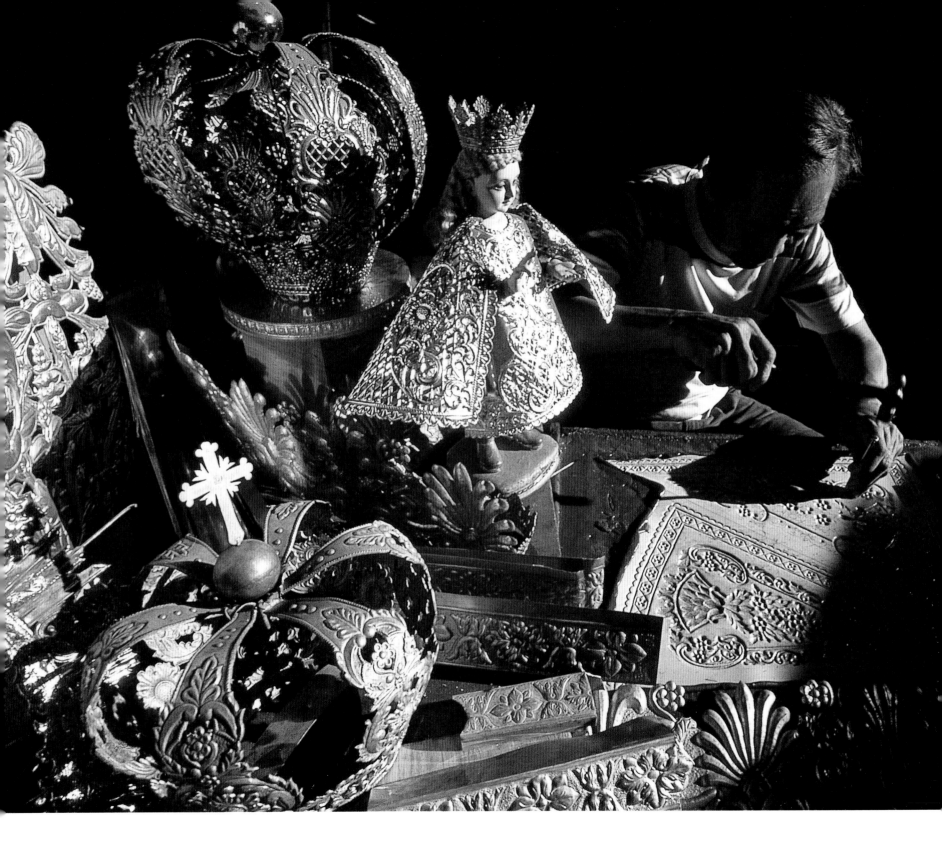

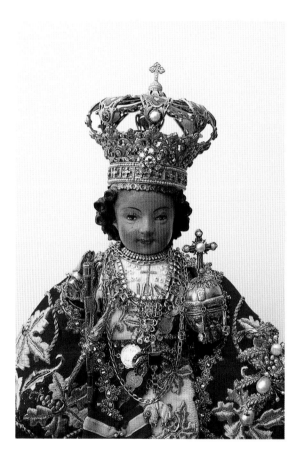
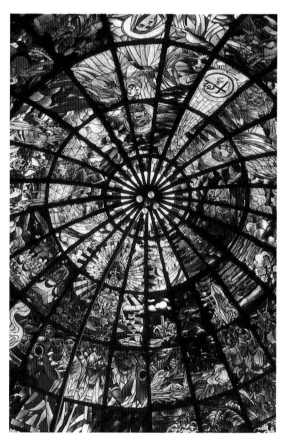
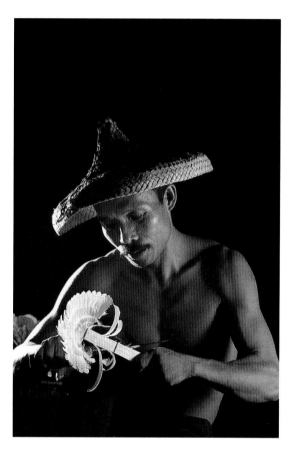

Above: Artistic creations often offer homage to spiritual pursuits, as seen in this delicately-garbed wooden carving of the *Santo Niño*, and a stained-glass dome with a modernistic religious mural. The woodcarver is a fixture in the lakeshore towns around Laguna de Bay southeast of Manila.

Left: The art of brassware used to be a specialty among the Muslim craftsmen in Mindanao, in the deep south, but has since been taken up by informal guilds in the rest of the country, where again the utilitarian purpose of rendering Catholic *objets d'art* is served.

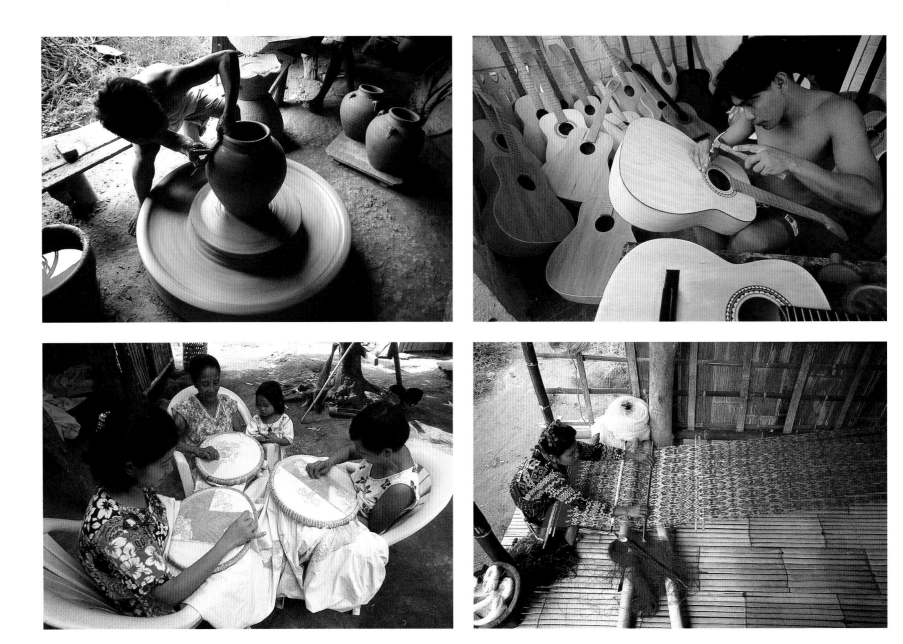

Above, clockwise from top left: In Ilocos Norte in northern Luzon, local potters produce large jars called *burnay* for fermenting native wine or storing rice and other grains. Handcrafted guitars are among the best-selling products of Cebu. In southern Mindanao, T'boli weaving generates substantial income for a cultural community. Embroidery occupies the womenfolk in the Southern Tagalog region in Luzon.

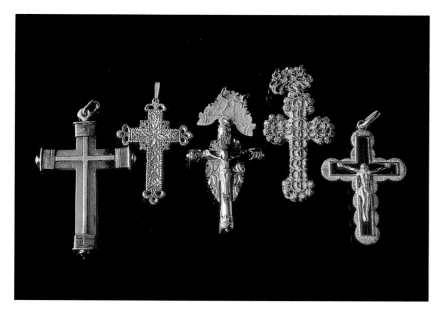

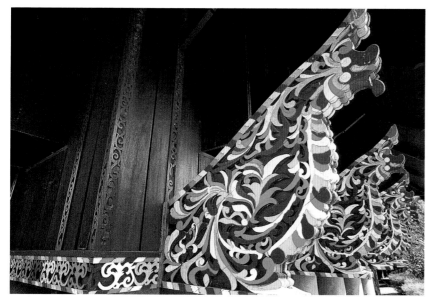

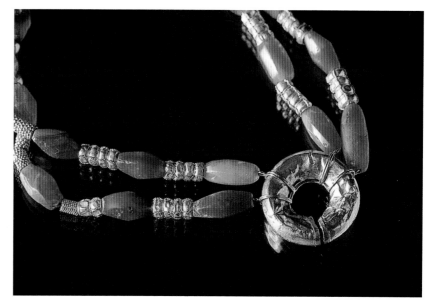

Above, clockwise from top left: Ornate crucifixes are among the highly stylized creations of craftsmen all over the archipelago. In Ifugao province, home of the Banawe rice terraces, utilitarian objects such as bowls and baskets unfailingly feature design embellishments. Tribal jewelry prides itself in elegant craftsmanship. In Muslim Mindanao, the architectural feature called *okir* is a must for privileged residences.

"It is still possible for an airline (which shall be nameless) to describe the Philippines in a television advertisement as "a lovely cluster of islands peopled by lovelies," for there are, admittedly, a few lovelies scattered about. But it is no longer possible, if it ever was, to think of the Philippines as the most carefree of combinations, a land of the morning where it seemeth always afternoon."

— Horacio de la Costa, S.J., *Selected Essays on the Filipino and His Problems Today*

THE MANY FACES
OF 'PARADISE'

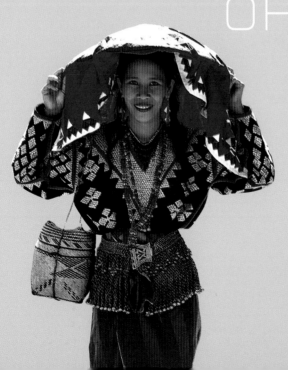

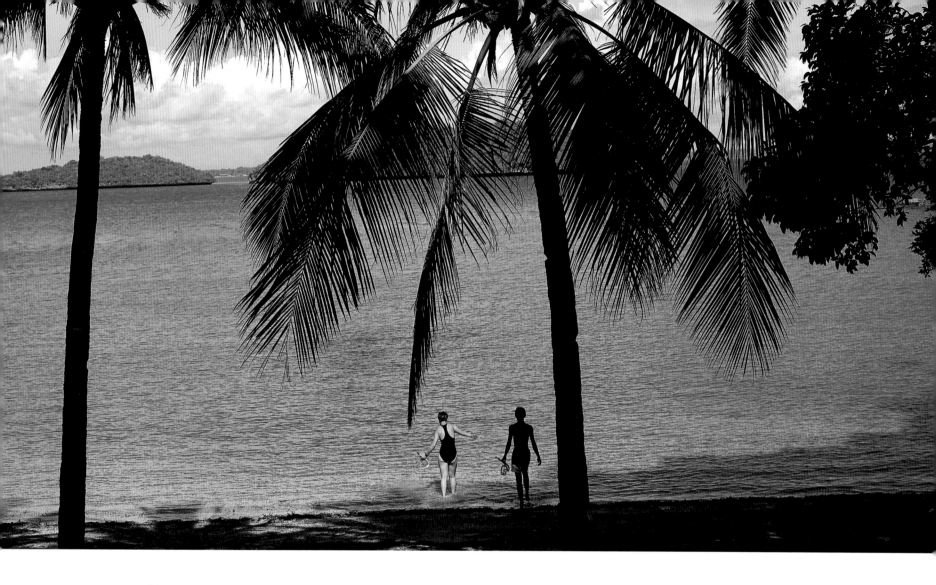

"Manila is not the Philippines," a first-time visitor hears from new-found friends as he sets foot in the usual gateway to the archipelago. Indeed, rolling out of the international airport and seeing the jostling crowds and the apparent chaos in the streets – likely occasioned by odd-looking contraptions called jeepneys – one may shudder at the wisdom of visiting yet another Third World country that instantly looks dysfunctional.

The roads toward the hotel districts display more of the same – small jerry-built shops standing chockablock and looking palpably symbiotic with the pedestrian commerce, sudden rows of shanties, naked brown men stroking their favorite game fowl while idling on street corners, garbage heaps here and there . . .

And yet, just behind those high walls on either side of the busy highway leading out of the airport, lying concealed are protected enclaves where the landscape is decidedly aesthetic, and the lifestyle as soothing as anything you can find in California. They somehow complement the cosmopolitan architecture in the central business districts of Makati, Ortigas Center or Alabang. And the

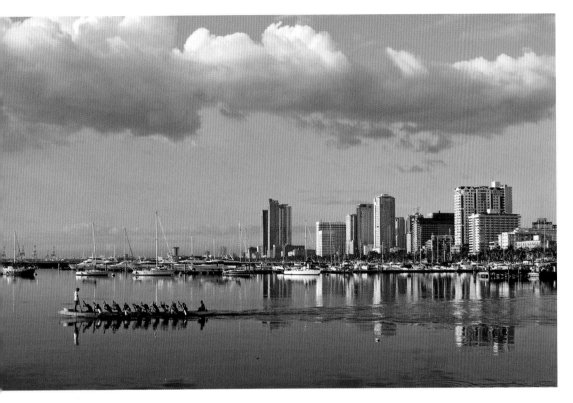

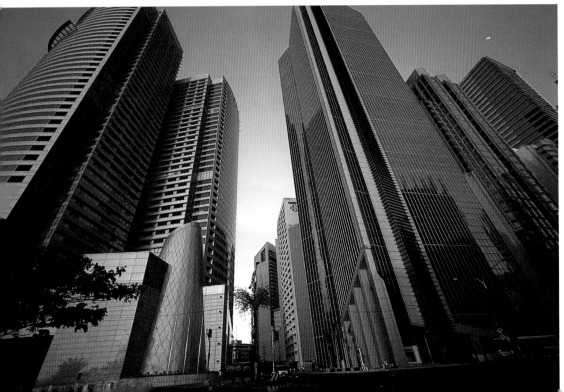

wonderment is occasioned anew: there seem to be two countries, even right here, or especially here in the primate city of central congestion.

There is much in Metro Manila that will dismay fresh eyes. And the sensitive Filipino knows this. He would want a visitor to share his country's favorable side. Thus he would offer what sounds like an apology when he urges a first-timer to go beyond the metropolis and enjoy the pleasures of the countryside, where there is a different Philippines.

But even Manila, as the urban sprawl is generically referred to – as distinct from Manila proper, or downtown Manila, or the City of Manila which served as the first capital – has many faces, each one fascinating, once beyond those surface extremes.

Poverty is a given in the densest districts. On the other hand, Metro Manila boasts of a plethora of fashionable malls and commercial centers with a dizzying array of food courts, elegant restaurants and nightspots. In fact the nightlife can be the poshest and most spirited in all of Southeast Asia.

Makati, the prime financial district, has its version of Wall Street in Ayala Avenue, with high-rises hugging one another to compose a dominant skyline. The Ermita and Malate districts –

Previous page, left: A T'boli maiden shows off her full regalia, including a hip adornment composed of strands of tinkling brass bells.
Previous page, right: The Hundred Islands off Alaminos in Pangasinan lend themselves to island-hopping.
Left, top: Manila shows off its yachts, hotels and tall buildings along Roxas Boulevard facing the famous Manila bay.
Left, bottom: The towering skyline of Makati City's Central Business District epitomizes the thrust into the future.
Right: A *calesa*, horse-drawn carriage, complete with driver and passenger, stands silhouetted against the Manila Bay sunset.

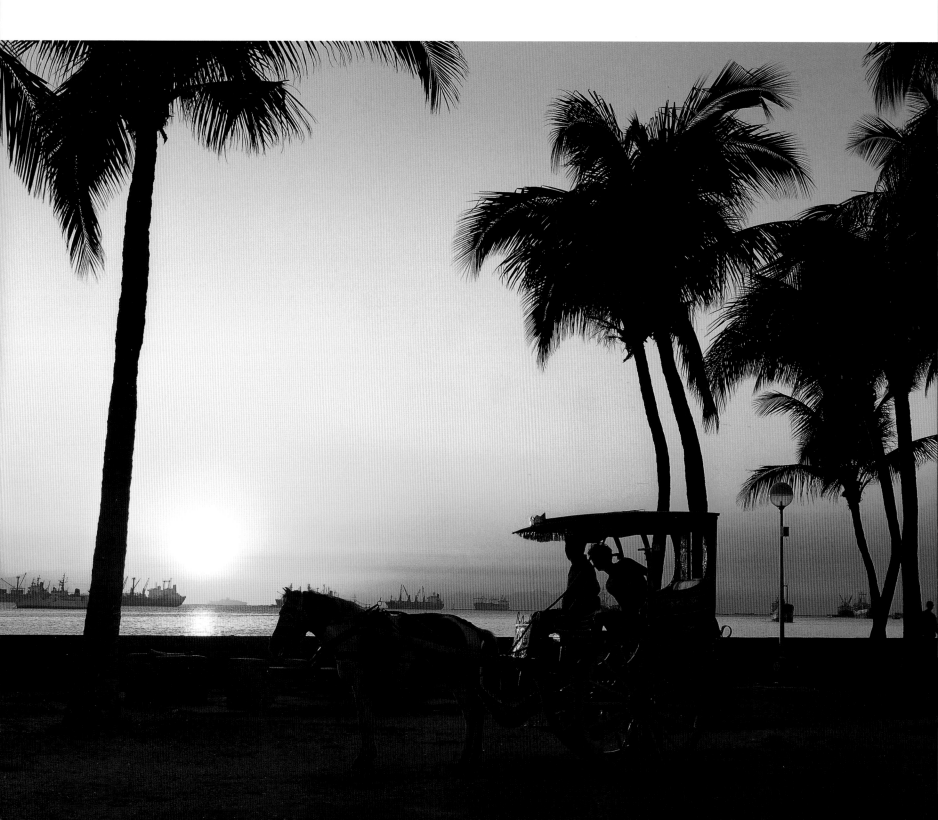

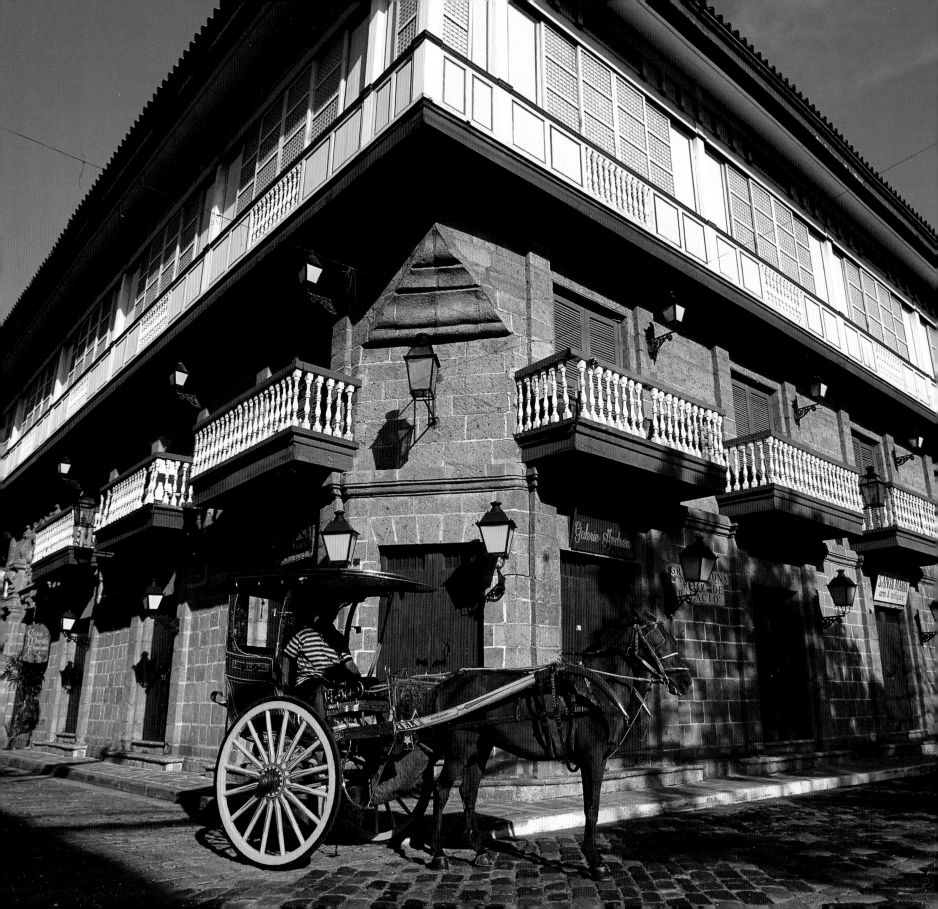

with the Ortigas and Libis areas coming a close second – attract yuppies, expatriates and backpacking foreigners for the bohemian ambience and music band venues. On Roxas Boulevard facing Manila Bay, expensive nightclubs, casinos, and videoke and sauna parlors are some of the other nocturnal attractions.

In the daytime, a good number of museums and art galleries cater to the cognoscenti. One may start at Rizal Park where the National Museum showcases Filipino masters' works. While in the area, a visit to nearby Fort Santiago and Intramuros is recommended for centuries-old churches and a stroll along the cobble-stoned streets, straight out of the colonial past, plus the national hero's memorabilia.

Here the *calesa*, the antiquated horse-drawn rig, still allows tourists a glimpse of former ways in the historic Walled City from whence Manila developed. Across the fabled if endangered Pasig River, which bisects the metropolis, Chinatown is found in Manila's Binondo district.

The national capital is a modern metropolis of harsh extremes, with slums and despairing canals sharing somehow in the 24/7 vibrancy of an urban mecca. Here the Golden Arches and the pizza parlor are as ubiquitous as the basketball court, while enclaves separate the economic classes as much as

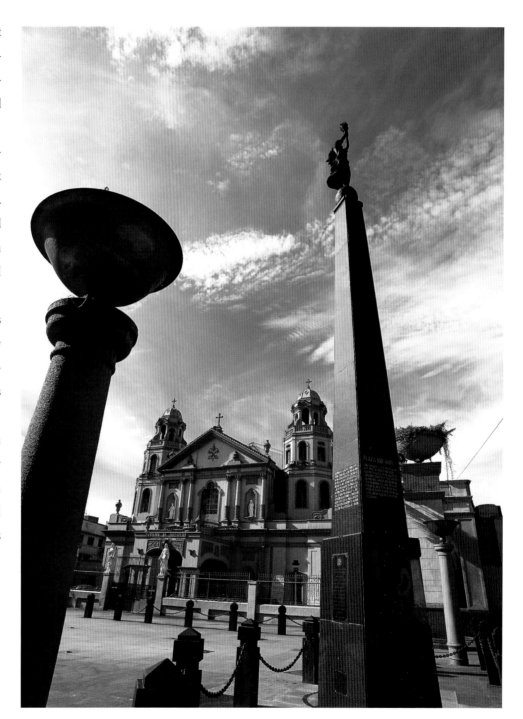

Left: A *calesa* awaits tourists in front of Casa Manila in Intramuros, the walled city built by the Spanish as early as 1571. Features of the colonial-era lifestyle are on display inside the building.
Right: Facing Quiapo Church in downtown Manila, Plaza Miranda has benefited from a recent beautification project. Due to its crossroads location, the church is one of the most popular in the country and is open all day long. The plaza continues to serve as a venue for public debate and political rallies.

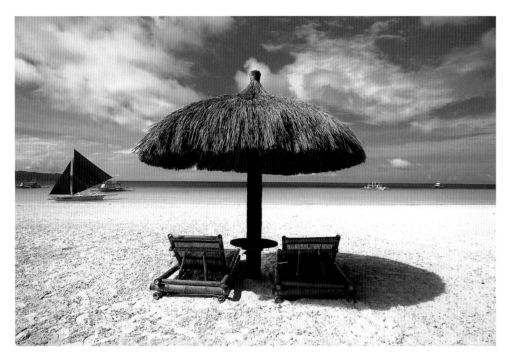

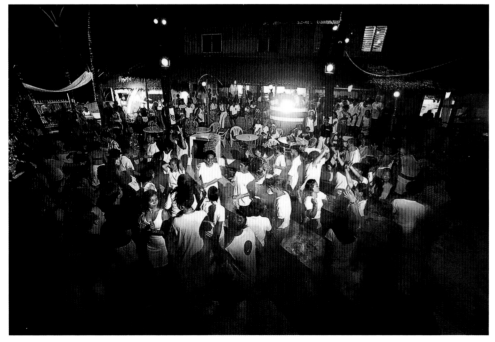

they distance the privileged havens amid all the human and vehicular traffic that defines the sprawl and the density.

Then there are the other Philippines. Take a bay cruise to Corregidor island for a capsule history of Filipino-American partnership in World War II. Little more than an hour south are the breezy provinces of Cavite and Batangas, themselves preserving historic memorabilia of the Spanish era.

Tagaytay City overlooking Taal Volcano and Taal Lake is a good stop for windswept viewpoints and flower farms. An hour beyond are the beaches of Batangas, thence Quezon province. The road deeper south leads through coconut country, all the way to the Bicol Peninsula and majestic Mt. Mayon.

North of Manila, the recreational haunts include Clark Field and Subic, the former U.S. bases that have been successfully turned into duty-free resort centers and industrial sites. The Ilocos region farther north is spartan country, where tobacco farmers eke out an industrious existence on arid strips of land between rugged mountains and the stretches of good beaches facing spectacular sunsets over the South China Sea.

Here is where the typical coastal attraction beckons for a fairer reckoning of the archipelago – the family and barrio life, the abiding humor and good cheer – as when you espy genera-

Left, top: Boracay by day is an expanse of powdery white sand, gentle surf and turquoise sea. This small island off Panay in the western Visayas has consistently been voted as having "the best beach in the world" by international travel magazines.
Left, bottom: Boracay by night turns into a plethora of bars, discos and beach parties. Part of the nocturnal fun on the main strip, White Beach, is the cheek-by-jowl presence of multi-cuisine restaurants and lively nightspots.
Right: Warm, limpid waters are among the top lures of tropical living.

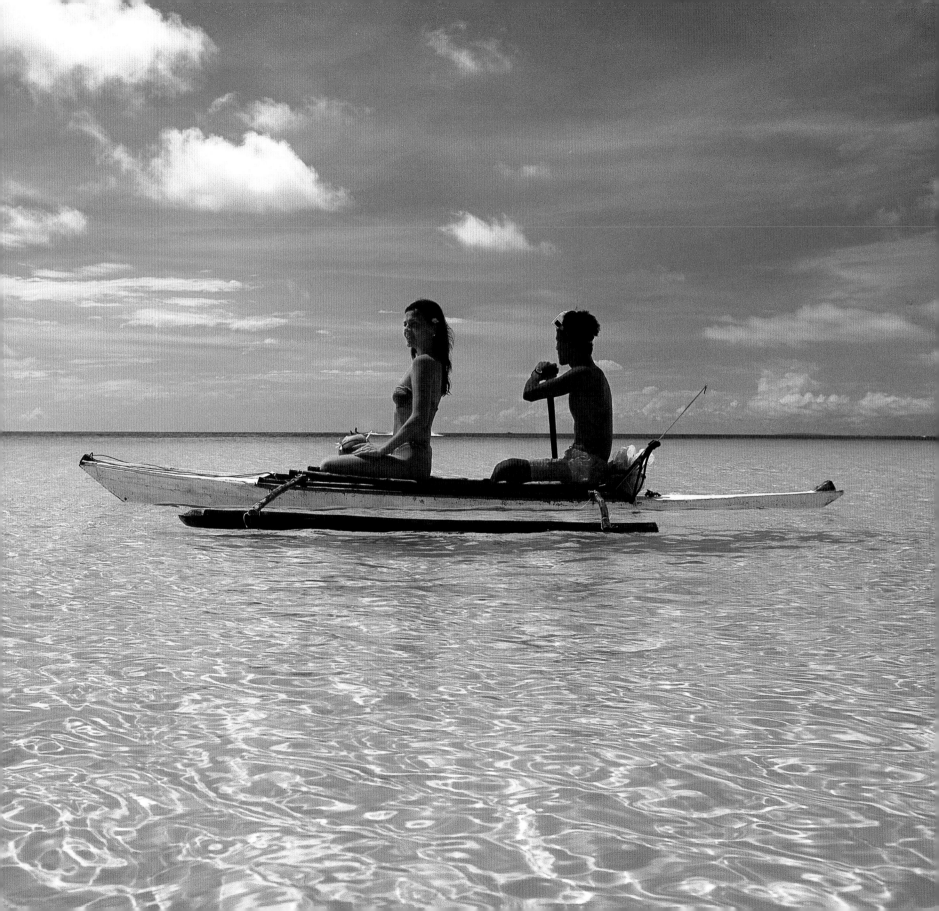

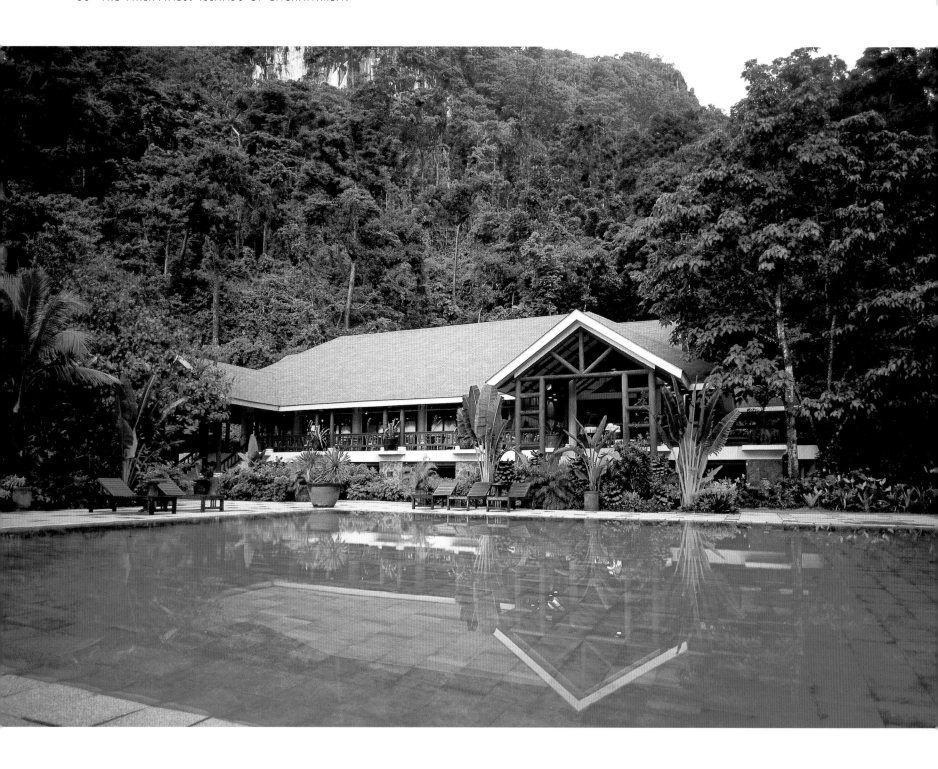

tions of sea-dependent villagers hauling in communal nets for the day's necessary catch.

The picture is repeated as you make your way down by boat or plane to the Visayas, where the islands are jewels of timelessness. Oh, a gaggle of children may follow you constantly about as you comb the shore; it is rare to find privacy where you're not treated as a stranger. Besides, their curiosity and friendliness are but tokens of the manner in which their elders will insist that you partake of the coco wine, or whatever sardines or tubers they may have for dinner. You are so quickly a part of an enchanted family.

It is the same in Mindanao, even in its troubled parts, as well as in all the marginal islands, islets and atolls where the rich biodiversity reflects the national sense of *horror vacui* as much as it does the generosity of native temperament. The gamut of experience lends itself to a chronicle of magic realism.

Perhaps the millions of Filipinos who take leave of their beloved homeland do so with the notion that they are simply displacing the country just enough so it can be shared more magnanimously while you are here.

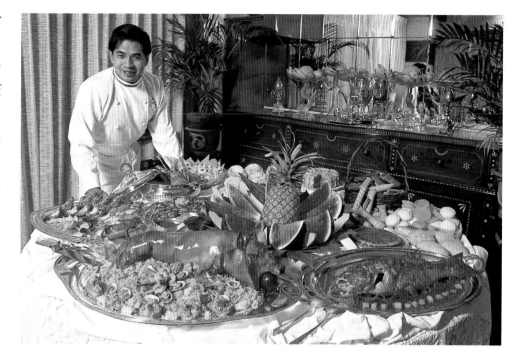

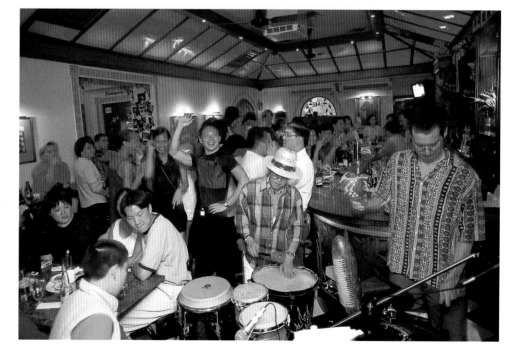

Left: Off the Palawan mainland, an elegant clubhouse and large pool are among the attractions set within the lush vegetation and limestone cliffs of Lagen Resort.
Right, top: One of Manila's top chefs, Gene Gonzalez, prepares a bountiful table of traditional offerings, including the succulent *lechon* or spit-roasted suckling that is the standard feature on social occasions.
Right, bottom: The lively, carefree nightlife in the Malate district of Manila is epitomized in this scene from Cafe Havana, a popular restaurant and party place offering live music.

Right: Off Mindoro, south of Luzon, Apo Island is a popular haunt for scuba divers. Offshore, coral reefs abound, and the warm waters are crystal-clear and clean, giving birth to a bountiful marine environment.
Far right, top: A small ferryboat plies the Hundred Islands group off Alaminos town in Pangasinan province, Luzon. The popular tourist destination features hundreds of uninhabited isles, several of which offer sandy beaches and amenities, apart from small caves and good diving.
Far right, bottom: The gorgeous Twin Lagoon at Coron Island, off Palawan.

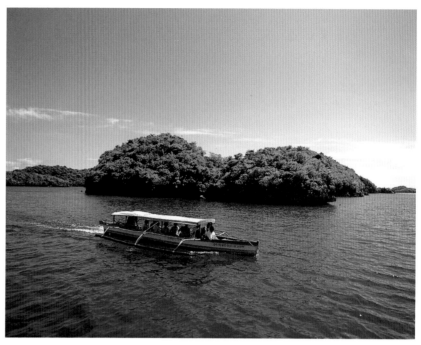

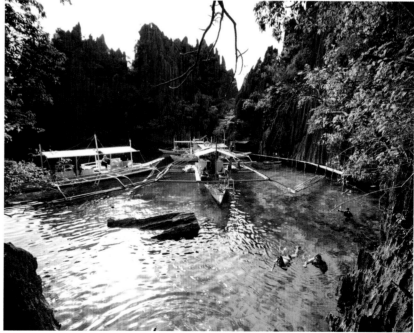

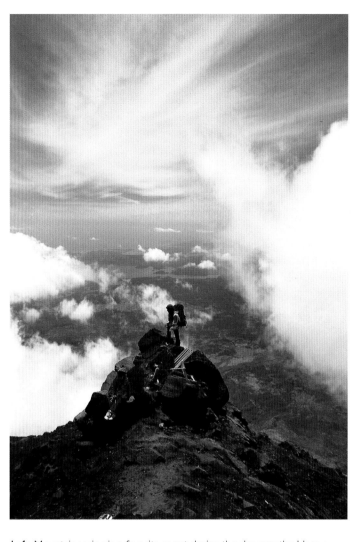

Left: Mountaineering is a favorite sport during the dry months. Here a climber savors the view from a secondary peak of the country's tallest mountain, Mt. Apo in Mindanao. The extinct volcano stands at over 3,000 meters. Called Apo Sendawa by natives, it is regarded as a sacred entity.
Above: Climbers conquer the craggy Knife Edge peak on Mt. Pulog, the second tallest mountain in the country, which caps the Cordillera range in northern Luzon.

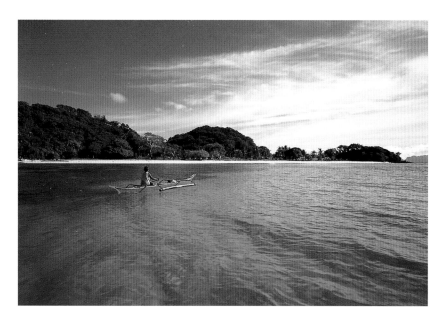

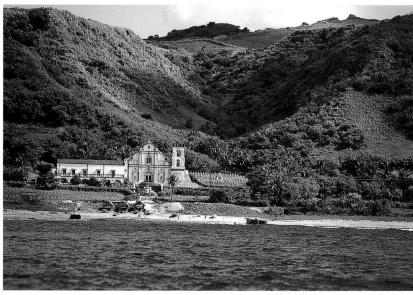

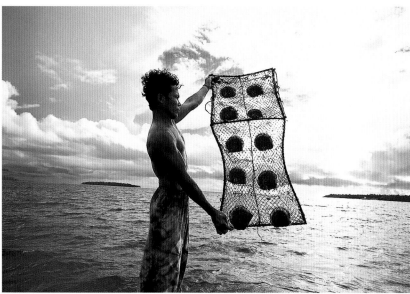

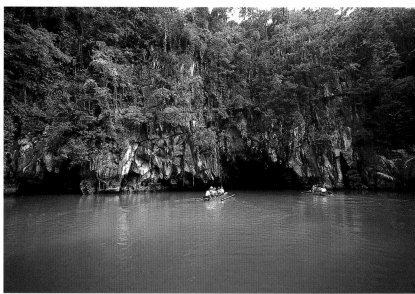

Above, clockwise from top left: The cluster of lovely islets off Busuanga, north of Palawan, are a diver's haven for their rich coral reefs and sunken vessels. Nestled below verdant hills is the 18th-century San Jose Church in Barangay Ivana on Batan Island north of Luzon. In Palawan, a major attraction is the St. Paul's Underground River in Sabtang town, a few hours' ride from Puerto Princesa. A pearl farm worker on Bugsuk Island off Palawan inspects oysters set in a woven contraption.

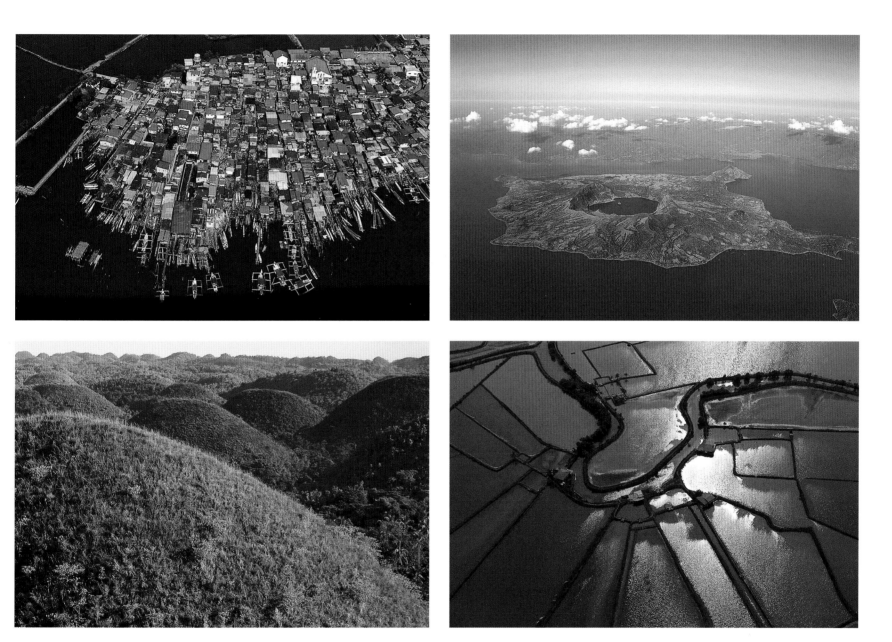

Above, clockwise from top left: A fishing community in Bulacan province north of Manila tends to a network of fishpens. Taal Volcano is an active crater in Taal Lake, itself a larger crater whose western ridge hosts the lake-view resort city of Tagaytay, a 90-minute ride south of Manila. Fishponds utilize a marshy area in Bulacan. The Chocolate Hills of Bohol are a much-visited geological attraction.

SELECTED FURTHER READING

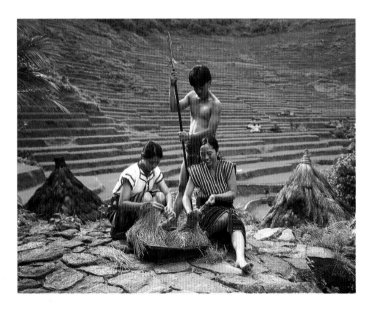

Above: Maidens separate chaff from rice grains as a loin-clothed warrior looks on in Battad, an upland village in Ifugao province.

100 Events That Shaped the Philippines, National Centennial Commission and Adarna Book Services, 1999

Being Filipino, ed. Gilda Cordero Fernando, GCF Books, 1981

Filipino Children's Favorite Stories, Liana Romulo with illustrations by Joanne de Leon, Periplus Editions, 2000

Filipino Style, Rene Javellana, Fernando Nakpil Zialcita and Elizabeth V. Reyes, with photographs by Luca Invernizzi Tettoni and Tara Sosrowardoyo, Editions Didier Millet, 1997

The Food of the Philippines, Reynaldo G. Alejandro with photographs by Luca Invernizzi Tettoni, Periplus Editions, 1999

Into the Mountains: Hostaged by the Abu Sayyaf, Jose Torres Jr., Claretian Publications, 2001

Key Conservation Sites in the Philippines, Aldrin Mallari, Blas Tabbaranza Jr. and Michael Crosby, Bookmark Inc., 2001

Lugar: Essays on Philippine Heritage and Architecture, Augusto F. Villalon, Bookmark Inc., 2001

Palacio de Malacañang: 200 Years of a Ruling House, Nick Joaquin, ed. Alfredo Roces, Society for the Preservation of Philippine Culture Inc., 2002

The Roots of the Filipino Nation, Volumes I and II, O.D. Corpuz, Aklahi Foundation, Inc., 1989

Sayaw: Philippine Dances, Reynaldo Gamboa Alejandro and Amanda Abad Santos-Gana, National Bookstore Inc. and Anvil Publishing Inc., 2002

Tropical Interiors: Contemporary Style in the Philippines, Elizabeth V. Reyes with photographs by Chester Ong, Periplus Editions, 2002

Tropical Living: Contemporary Dream Houses in the Philippines, Elizabeth V. Reyes with photographs by Chester Ong, Periplus Editions, 2000